All About
Antiquing and
Restoring Furniture

All About
Antiquing and Restoring Furniture

by Robert Berger

Hawthorn Books, Inc.
Publishers
New York

ALL ABOUT ANTIQUING AND RESTORING FURNITURE

Designed by Harold Franklin

Library of Congress Catalog Card Number: 77-130711

ISBN: 0-8015-0138-5

4 5 6 7 8 9 10

Acknowledgments

I would like to thank the following companies for their enthusiastic cooperation in supplying technical information and photographs:

Adelphi Paint and Color Works, Inc.
Adjustable Clamp Company
Albert Constantine and Son, Inc.
American Brush Company
American Brush Manufacturers Association
American Machine and Tool Company, Inc.
Arco Tools, Inc.
Armour Industrial Products Company
Baker Brush Company
Benjamin Moore and Company
Bentley Products, Inc.
Black and Decker Manufacturing Company
Campbell-Hausfeld Company
The Carborundum Company
David Linzer and Sons, Inc.
Deft, Inc.
Delta Power Tool Division of Rockwell Manufacturing
 Company
Devcon Company
E. I. du Pont de Nemours and Company
Elliot Paint and Varnish Company
Fine Hardwoods Association
The Glidden Company
Illinois Bronze Powder and Paint Company
Industrial Products Company
Johnson Wax
Krylon Company
McCloskey Varnish Company
Minnesota Mining and Manufacturing Company
Minwax Company
National Paint, Varnish and Lacquer Association

Nemo Tile Supplies
Norton Company
Otto Bernz Company, Inc.
Pierce and Stevens Chemical Corporation
Plasti-Kote, Inc.
Pratt and Lambert, Inc.
Red Devil Tools, Inc.
Rez Company
Rockwell Manufacturing Company
Rust-Oleum Corporation
Samuel Cabot, Inc.
Sapolin Paints, Inc.
Savogran Company
Sherwin-Williams Company
Smith Victor Corporation
Swingline, Inc.
Turner Corporation
United States Ceramic Tile Company
United States Plywood Corporation
USM Corporation
Valspar Corporation
Western Wood Products Association
William Zinsser and Company, Inc.
Wilson-Imperial Company
Woodhill Chemical Company
W. R. Brown Corporation

—R. B.

Contents

vii

All About
Antiquing and
Restoring Furniture

Repairing

Furniture Surfaces,

Joints, and Parts

✿✿✿✿✿✿✿✿✿✿✿✿✿✿✿✿✿✿✿✿✿✿✿✿✿✿✿✿✿✿✿✿✿✿✿✿ If your home has the usual complement of little children, big dogs, and happy parties, it's a pretty safe bet that your furniture bears the scars of combat. Fixing these stains, scratches, burns, gouges, and similar ailments is a lot easier than you might think with the tricks of the trade we'll tell you about. Let's get to work!

Water Marks

Wet glasses and vases can make an absolute mess of a finely finished tabletop. To remove water spots and rings, rub the surface with a liquid furniture wax and 4/0 steel wool. Be sure to work with the grain and use light pressure.

If this fails, place a clean, thick blotter over the water mark and press with a warm iron. To avoid scorching the wood, apply the iron only briefly. Continue until the spot is removed.

Another effective technique is to polish with rottenstone and oil. Rottenstone is a very fine abrasive powder that you can buy at paint-supply stores. A handy way to use it is to put it in a salt shaker. After applying sewing-machine oil or salad oil to the blemish, shake out enough rottenstone to make a paste. Rub with the grain of the wood, using a clean, soft cloth. Wipe frequently so that you'll be able to check your progress.

After you've restored the surface, wax it thoroughly. Wax won't prevent damage when water is allowed to remain on

1

the surface indefinitely, but it will provide some protection and give you more time to mop up before the surface becomes marked.

Ink Stains

A desk or tabletop that has an old ink stain is very likely a candidate for a complete refinishing job. In fact, the only time that you'll have even half a chance to remove an ink stain is immediately after you've tipped the inkwell. When that happens, blot up as much of the ink as you can; then apply a wax such as Johnson's Jubilee, following the directions on the label. Or try patting the stain with a damp cloth. Don't rub; keep turning the cloth so that you are always working with a clean section. If the stain remains, rub the area with rottenstone and oil.

Alcohol Spots

Spilled perfumes, medicines, and beverages containing alcohol should be wiped up as quickly as possible because they have a solvent effect on almost all finishes. If the surface has been waxed, there may be no spot. If there is one, put furniture polish, car cleaner, silver polish, or linseed oil on your fingertip and rub the spot. Even moistened cigarette ash rubbed over the spot may be abrasive enough to do the trick.

If the fingertip treatment doesn't work, put a few drops of ammonia on a damp cloth and rub the spot. Then wax the surface immediately.

For stubborn alcohol spots, try a paste of rottenstone and oil. Apply this to the spot with a soft cloth; rub with the grain of the wood. For faster results, FFF powdered pumice and oil may be used, but rottenstone will still be needed for final polishing.

No matter which spot-removal method you use, wax the surface carefully after you've finished the job.

Milk Stains

When milk, ice cream, custard, or other foods containing milk or cream are allowed to remain on furniture, the lactic acid they contain will act like a mild paint remover. It's important to wipe the surface as soon as possible. Then clean it with a furniture wax and follow the same procedure as for alcohol spots.

Candle Wax

You'll find that wax is easy to remove if you harden it first by holding an ice cube against it for a few seconds. Wipe up any melted ice immediately, then crumble off as much wax as you can. Gently scrape away the rest with a dull knife. When all the wax is removed, rub the surface briskly with furniture wax, then wipe dry with a clean cloth.

Heat Marks

White blemishes caused by heat are tough to remove. But before surrendering to a complete refinishing job, try lightly rubbing the spot with a cloth moistened with camphorated oil. (Don't use a linty cloth—its fuzz may adhere to the wood. An old handkerchief is best because many launderings will have made it nearly lint-free.) Then wipe immediately with a clean cloth. If the surface feels rough, rub with 4/0 steel wool and light lubricating oil. Blemishes that resist these efforts should be rubbed with rottenstone and oil. On a varnished or shellacked surface, heat marks often succumb to a cloth dampened

with spirits of camphor or essence of peppermint. Daub the spot, then allow it to dry undisturbed for at least thirty minutes. Finally, rub with rottenstone and lubricating oil.

Minor Scratches

Apply paste furniture wax with a pad of 3/0 steel wool, rubbing lightly with the grain. After polishing, if you can still see the scratch, remove the wax with a cloth saturated with naphtha. Be sure that all the wax is off so that the surface will be able to absorb coloring to hide the scratch.

The oil from a Brazil nut, black walnut, or butternut may provide enough coloring, particularly on a walnut finish, to hide a minor scratch. Break the nut in half and rub it into the scratch. A rubbing with linseed oil may also cover the scratch.

A brown coloring crayon makes a good scratch hider, or try wax sticks that are specially made for furniture touch-up work. They come in a variety of wood tones and look somewhat like crayons but are softer and easier to use. After filling the scratch with wax, rub with your fingertip, then wipe with a soft, dry cloth.

Even paste shoe polish can be used. Apply it to the scratch with a cotton swab or cotton-tipped toothpick, then buff dry. If the polish is too dark, wipe it off with naphtha. On your next try use either a lighter shade of shoe polish or one of the other coloring materials suggested here. Of course, the easiest scratches

Many manufacturers produce easy-to-use wax sticks for repair of minor surface defects.

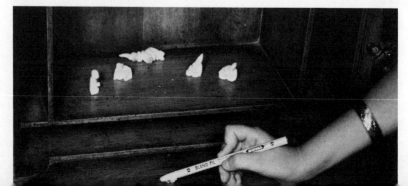

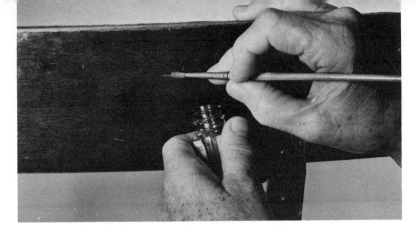

Apply iodine with a fine brush to mask scratches on maple or mahogany finishes.

to fix are those on black lacquered wood. All you have to do is apply a bit of black paste shoe polish. Keep in mind when using shoe polish for scratch touch-ups that the polish will shine when buffed. If the furniture has a dull finish, the repair may be conspicuous.

Scratches on red mahogany are easy to hide with iodine. Apply it carefully with a very fine brush. A size 0 artist's brush is the best size, but you can get by with a cotton swab. On brown mahogany, use old iodine that has turned dark brown with age. For an accurate color match on maple, dilute iodine about 50 percent with denatured alcohol. After applying iodine and allowing it to dry, wax the surface and buff it well.

Another scratch remedy is the ever-reliable rottenstone and oil. This should be used as explained under "Water Marks."

Deep Scratches

Stubborn scratches that resist cunningly applied nut oil, iodine, crayon, and other simple remedies should be handled like this:

Remove old wax and oil with a rag saturated with naphtha. Then select a penetrating oil stain that most closely matches the color of the wood. It may be necessary to mix two stains together for an accurate color match. If necessary, turpentine can be added to lighten the stain. An old white saucer provides a good mixing surface and makes it easier to judge the color precisely. Apply the stain with a finely pointed brush. After wiping, if the color is too light, apply more stain. Allow the stain to dry over-

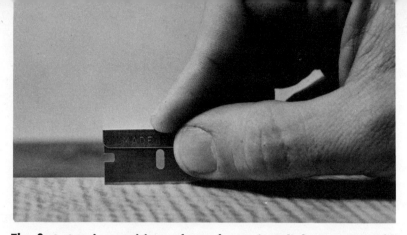

The first step in repairing a burned spot is a light scraping with a razor blade held at right angle to surface.

night, then seal the stain with white shellac. Build up several layers of shellac, allowing at least four hours between coats. After you have applied enough shellac to fill the scratch, smooth the repair with extra-fine sandpaper. To level the surface accurately, it's best to work with a small sanding block. As a finishing touch, rub with rottenstone and oil. Follow this with paste wax and a buffing.

Cigarette Burns

Begin by scraping away all charred wood with a new single-edged razor blade. To avoid cutting into the wood, hold the blade perpendicular to the surface. Then clean the damaged area with naphtha on a cotton swab.

After smoothing with extra-fine sandpaper, mix and apply stain as described in the section on deep scratches. When the stain is dry, fill the damaged area with matching stick shellac. Scrape off excess shellac with a razor, then sand the repair. If the sanding bares wood around the shellac, touch up with stain. Finish by rubbing with rottenstone and oil, then wax the surface.

Gouges and Dents

The usual way to repair a gouged spot is to fill it with Water Putty or Plastic Wood. If the gouge is shallow, however, patching may not be necessary. For example, where the damage is

on an edge, simply rounding the entire edge with sandpaper may do the job. Even where the gouge is in the middle of a panel or tabletop, sanding might very well eliminate the defect. Of course, this may result in a fair amount of touch-up work or even complete refinishing because your sanding won't be confined to the gouge alone. You'll have to work over a large-enough area so that you can blend out the damaged spot.

On the other hand, if the gouge is shallow enough to be sanded away, you're far more likely to wind up with an inconspicuous repair than if you had resorted to patching.

When patching is necessary, your main concern should be to match the color of the wood as accurately as you can. If you use Plastic Wood, you can choose any one of five wood colors. If necessary, two or more colors may be mixed to get the shade you need. Sometimes the best method is to use natural-color Plastic Wood and then touch up the repair with a penetrating oil stain to match the surface.

Durham's Water Putty may be mixed with dry colors, which are available at paint shops, to produce the desired color. Penetrating oil stain or water stain can also be used for touching up. If you've never worked with Water Putty or Plastic Wood, you may want to experiment first on some scrap pieces to get the feel of color mixing and application.

Though dents may seem hard to fix, they don't really pose much of a problem. Deep dents should be repaired with stick shellac. Shallow dents usually respond to steaming. This swells the wood fibers until they are restored to their normal size.

As a first step, clean the area to be steamed with trisodium phosphate or turpentine. Place a damp, folded cloth over the dent and apply moderate heat with either a soldering iron or a household iron. If you avoid overdoing the heat treatment, the finish is unlikely to be harmed. Repeated applications of heat and moisture will probably be needed to lift the dent. If the dent occupies only a small area, lay a metal bottle cap or thimble, open side up, on the cloth. When you hold the iron against the cap, the steam will be concentrated on the dent.

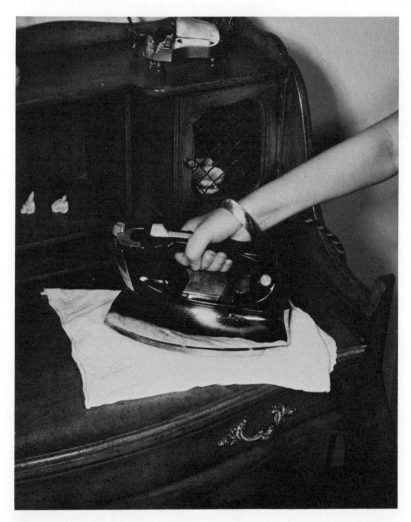

Effective treatment for a dent is application of steam with damp cloth and household iron.

Minor dents can often be raised without using heat. With a needle, prick tiny holes in the dent. Then dip your finger in water and apply a few drops to the dent. The holes will help the surface absorb the water and swell the wood fibers. Don't be concerned about the holes; they will disappear after you apply water.

If heat and moisture have dulled or spotted the surface, rub lightly with rottenstone and linseed oil to restore the finish.

Stained Marble and Tile Tops

If you have a lengthy list of home projects to tackle and one of the jobs is removing a stain from a marble- or tile-top table, that's the one deserving top priority. The reason, of course, is that if allowed to remain, the stain will become so firmly set that removal may be all but impossible. Prompt attention is especially important for tile because the grout joints are rather absorbent and may become deeply stained if neglected.

Stains can be caused by such a wide variety of substances that no single cleaning agent can handle all problems. If the cause of the stain isn't known, you'll have to do some testing. The stain may be soluble, so begin by applying a mild solvent such as trisodium phosphate or a cleaner containing it such as Spic and Span. If the stain resists, apply ammonia. If that doesn't work, try turpentine or white vinegar. If none of these succeed, the stain probably won't respond to any solvent, and it's time to try bleaching. Start by applying a laundry bleach and work up to more active chemicals such as 20-volume hydrogen peroxide or ammonia, if necessary.

Stains that don't respond to either solvents or bleaches may have to be polished out with abrasives. Again, the best plan is to begin with a mild cleaner and graduate to something stronger only if necessary. Steel wool and scouring powder should be tried first, then fine wet-or-dry sandpaper. On glazed

tile, however, sandpaper should not be used, because it may scratch the surface.

When the stain is identifiable, removal is easier because testing isn't necessary. For coffee, tea, fruit juice, and food stains, trisodium phosphate generally works well. If the stain remains, laundry bleach should be used. Fingernail-polish stains can be taken out with amyl acetate or nail-polish remover. Bloodstains are best removed with trisodium phosphate and cold water. They can also be bleached with hydrogen peroxide. Ink stains don't respond to solvents. Instead, use laundry bleach or peroxide. For grease spots, apply a mixture of 1 part sal soda to 9 parts water.

When using a solvent or bleach, don't rush things. Usually, fifteen to thirty minutes will be needed for the chemical to take effect.

After applying any chemical and allowing it time to work, it's important to wash the surface completely clean with hot water and dry it promptly. Because even the milder agents may irritate skin, rubber gloves should be worn.

Loose Joints

When your favorite chair develops rickety joints, you probably won't bruise anything more than your dignity if the chair should cave in. But repairs are so simple to make that there's no point in taking such chances.

Joints, even in well-constructed furniture, may loosen. This is most likely to happen in winter, when the combination of hot radiators and low humidity dries wood fibers and causes shrinkage. Chair rungs are especially vulnerable.

If the rung can be removed, it will make your work easier. Simply scrape away the old glue from both the rung and its socket. Then apply fresh glue and reinstall the rung.

While the glue dries, the parts must be held tightly together

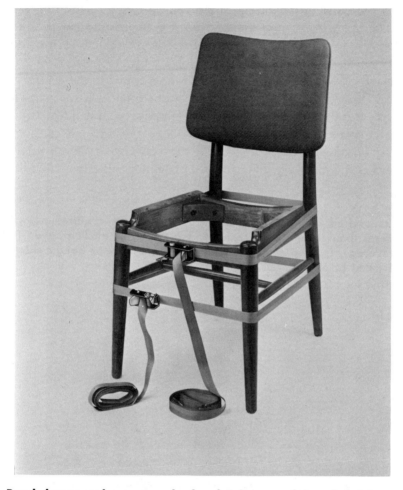

Band clamps make easy work of such jobs as regluing chair joints.

with bar clamps or a band clamp. The band clamp, a beltlike affair, is particularly handy for this work. But it isn't absolutely necessary to have fancy clamps. You can improvise a Spanish windlass, for example. Use strong, soft cord such as clothesline

and a stick or dowel to form a tourniquet. After winding the cord around the chair legs, insert the stick underneath the cord. Then twist to tighten the cord until there is sufficient pressure on the joint. Tie the stick so that the cord doesn't unwind. When repairing fine furniture, don't forget to protect the surfaces with cloth or other padding before applying the clamp.

When wood shrinkage has been so extreme that the parts fit very loosely, the use of a resorcinol glue is recommended. It not only creates an enormously strong bond but also has excellent gap-filling properties. In fact, if the rung is very loose in the socket, it's unlikely that any other common adhesive will work

Improvised clamp, called a Spanish windlass, requires nothing more than some strong twine and a dowel or kitchen spoon for leverage. To keep the twine under tension, the spoon handle should be tied in place.

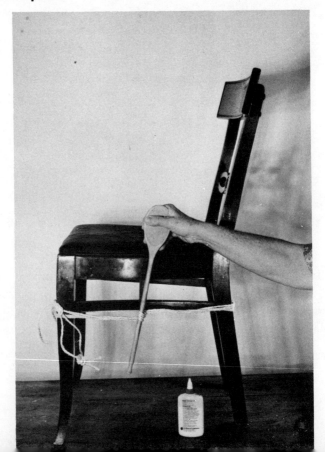

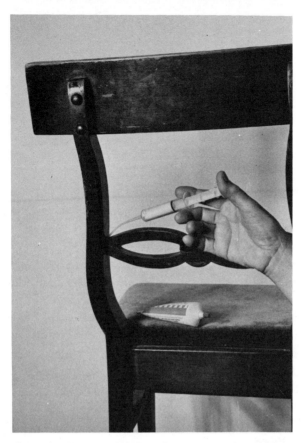

Grip-Wood is an effective product for repair of wobbly joints because of its wood-swelling properties. A handy syringe is provided for application.

satisfactorily. One caution: When using a resorcinol glue, apply it carefully. It is a chocolate-brown color, and if any glue oozes out of the joint, it will permanently stain the wood and make the repair noticeable.

An especially easy way to fix a loose rung or spindle is to drive a metal fastener into the end of the rung or spindle. The fastener has fishhooklike barbs that hold securely in the socket. Fasteners of this type are a standard item at any dime store.

There are also specialized products such as Devcon Grip-Wood that do a remarkably effective job of snugging up loose joints. Grip-Wood has both adhesive and wood fiber–swelling properties. It comes in a squeeze tube and should be applied to both surfaces, which are then clamped and allowed to dry for one hour. The manufacturer also makes a large plastic syringe

that is valuable for injecting Grip-Wood when a rung is wobbly but not removable.

Even with a syringe there may be times when there's not enough space to force in adhesive. Drilling a small hole through the leg will expose the tip of the rung and allow enough room for the syringe to enter. After the adhesive has dried, the hole can be plugged with Water Putty or Plastic Wood.

Don't expect miracles with either resorcinol glues or wood-swelling adhesives. There is a definite limit to how much gap-filling or swelling they can do. Here are several gap-filling tricks: On very poorly fitting joints, apply glue to the rung, then wind it with string to improve the fit. Apply more glue to rung and socket before assembling. If the fit is very sloppy, saw a slot in the end of the rung. Then drive in a wedge, just as is done in the end of a hammer handle. Apply glue to the rung and socket, then assemble.

Warped Wood

Of all the furniture in your home, the pieces most likely to warp are those having large surfaces that are not adequately fastened to a rigid frame. Drop-leaf tabletops and desk tops are typical examples.

Flattening a warped board is one of the toughest furniture-repair jobs that you are apt to tackle. The usual techniques and equipment that professionals depend upon, such as steam boxes, are not practical for the do-it-yourselfer.

A method that works fairly well if the warp isn't severe is to lay a blanket or heavy towel on the concave side of the board and keep wetting the cloth with hot water until the board flattens.

Once the board is flat, it must be held that way, or it will warp again as it dries. A tabletop doesn't usually present a problem because it can be anchored flat with screws driven from

underneath, but a hinged leaf is another matter entirely. Here, the best bet is to attach hardwood cleats with glue and screws to the underside of the leaf. The cleats should be cut and drilled in advance so that there is no delay after the board has been flattened.

Though the hot water may correct the warp, it will not have a beneficial effect on the finish or on joints that have been assembled with water-soluble glue. So if you choose the water treatment, bear in mind that you may be in for a regluing and refinishing job after you've flattened the board.

If you have a table saw or a portable circular saw, you can attack the problem in another way. By running a number of lengthwise saw kerfs about 1″ to 1½″ apart on the convex side you can eliminate the stress and flatten the board. Adjust the saw blade for a cutting depth of about three-fourths of the board's thickness. Because you're working on the underside, the repair will not be conspicuous as long as your saw cuts don't extend all the way to the ends of the board.

If you don't have a power saw, a cabinet shop or lumberyard can do the job for you.

The advantages of correcting warpage by sawing instead of by wetting are obvious: The finish is not damaged, glued joints are not disturbed, and the work can be completed in a fraction of the time.

Damaged Veneer

If a piece of veneer has broken off, let's hope that you were clever enough to save it. Remove the old glue from both surfaces by carefully scraping with a knife or razor blade. Take the time to do a thorough removal job because any remaining old glue will prevent proper adhesion. Then apply a nonstaining adhesive such as a plastic-resin glue, press the veneer in place, and clamp. Plastic-resin glues are made by various manufactur-

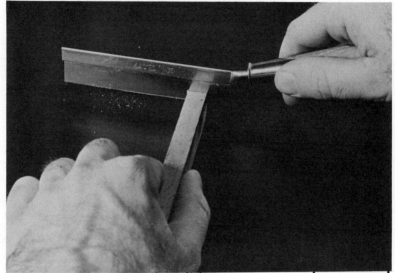

For very fine cutting, as when slicing a scrap to repair a veneered surface, an X-acto saw is ideal.

ers. All work effectively on veneer, edge-gluing jobs, and general cabinetwork, but adequate clamping is an absolute must.

If the broken veneer has been lost, or if it's too badly damaged to glue back, you may be able to get another piece from a cabinetmaking shop. It's likely that you'll need only a small scrap to make the repair. Be fussy when choosing veneer; try to get similar grain and an accurate color match if possible, or the patch may be conspicuous.

It's possible that you won't be able to buy suitable veneer. In that case you can make your own by cutting a thin slice from a board or block of the same wood species. If only a small strip is needed, use a plane to cut a shaving from the edge of the board. Vary the blade adjustment to get a shaving of proper thickness.

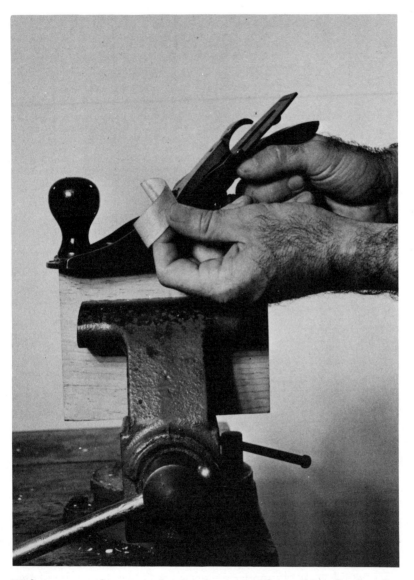

With care, a plane can be used to provide a thin shaving for
veneer repair.

Some suppliers such as Constantine & Son sell veneer sample kits. If the area to be repaired is very small, one of the pieces from such a kit may be used. The address of this company is given in the section listing suppliers.

Usually, the damaged area will have ragged edges; these must be trimmed before patching. Use a new single-edge razor blade. For an inconspicuous repair, the edges of the "grave," as cabinetmakers fondly describe it, should be cut along lines corresponding to the pattern of the grain. The shape of the grave may well resemble an amoeba by the time you've completed your surgery. If you can possibly manage it, try to bevel the edges of the grave by slanting the razor outward. The bottom of the grave will then be a hair smaller than the top, and you'll be well on your way to a very neat repair.

If cutting fancy free-form shapes seems too tricky, simply cut the grave in a diamond pattern. You'll have no trouble cutting the edges cleanly if you avoid cutting at right angles to the grain.

Make a pattern by placing a piece of thin paper over the grave and rubbing with your fingertip until the grave is outlined. Lay the pattern on the veneer to be used for a patch and trace its outline. When you cut the patch, slant the razor to bevel the edges just as you did when cutting the grave. Complete the job by cementing the patch as previously explained.

Veneer also likes to come undone along an edge. When this happens, lift the veneer carefully; if you lift it too high, you'll snap it off. To play it safe, have someone else hold the edge up while you poke underneath the veneer with a small knife blade and scrape away the old glue. Don't rush the job, or you may accidentally stick the knife point through the veneer. When everything is nice and clean, apply glue to both surfaces with a palette knife. Use a C-clamp padded with a piece of scrap wood to apply moderate pressure. Then undo the clamp and wipe away any glue that has oozed out. Cover the edge with waxed paper or aluminum foil to keep any more escaping

glue from adhering to the scrap. Refasten the clamp and the scrap wood.

Veneer that has blistered can be repaired in basically the same way. Operate on the blister with a razor blade. Make three cuts so that you can open the veneer like a tiny door. Scrape both surfaces clean and apply new glue. If clamping isn't possible, maintain pressure with a stack of books until the glue has dried.

Drawers That Stick

Usually all that is needed to unstick things is a bit of lubrication. A candle, paraffin, or a commercial preparation such as Door-Ease may be used. After brushing away lint and dust, apply lubrication along all contacting surfaces such as drawer guides and edges.

When lubrication fails to work, sterner measures are in order. Remove the drawer and carefully inspect edges and guides for

A lubricant such as Door-Ease applied to drawer grooves and guides will minimize friction.

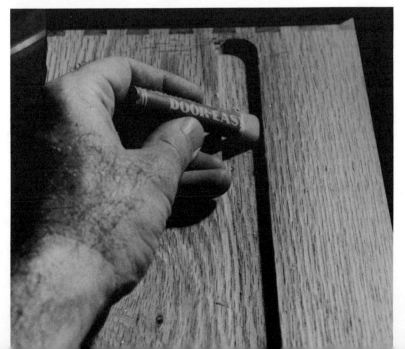

high spots that are causing binding. They'll be easy to find because the friction will have given them a shiny, almost waxed appearance. When you've pinpointed the trouble spots, eliminate them with a sanding block. A rasp or plane can be used instead and the job can be completed more quickly, but there is a greater risk of cutting away too much wood. No matter what tool is used, it's important to stop work frequently to test the way the drawer fits.

When you find that you have to lift the drawer to get it to close completely, don't bother with sanding or planing. Instead, remove the drawer and drive thumbtacks into the track on either side of the inside of the chest. The tack heads will provide an accurate bearing surface for the drawer. Tap the tacks in a little at a time, until they are at the proper level.

If the drawer opens only partially or not at all, bake it with a 200-watt bulb in a photo-light reflector. This will eliminate the moisture that has caused the wood to swell. It's a good idea to remove the drawer below the sticking one so that the bulb can be aimed in from underneath to allow the heat to rise. You may have to keep the bulb on overnight; position it so as not to scorch the wood.

Loose Hinges and Out-of-Line Doors

When hinge-screw holes become enlarged, making it impossible for the screws to bite and hold as securely as they should, remove the screws. The oversized holes should then be filled with Plastic Wood pressed firmly into place for good adhesion. After it has dried, the screws can be reinstalled. The holes can also be plugged with small slivers of matchstick glued in place. Where the holes are not badly enlarged, simply using the next-larger screw size may tighten the hinges, but this usually involves drilling or reaming the hinges so that they will accept the new screws.

To dry out moisture, apply heat with a 200-watt bulb, but be careful to avoid scorching wood.

If a door is out of line, be sure that all the screws are well tightened. Even a slightly loose screw may be causing the trouble by allowing enough play for the door to bind at some point.

If tightening the screws doesn't correct the door's alignment, find the spot that's binding by moving a thin piece of cardboard along the edge of the closed door. If the tight spot is along the top of the door, remove the upper hinge, insert a cardboard shim, and replace the hinge. To correct binding along the bottom edge, shim the lower hinge.

If shimming doesn't eliminate binding, trim the high spot with a well-sharpened block plane or smooth plane. It's best to remove the door so that you can work conveniently. To avoid chipping, plane inward from each corner. Before replacing the door, refinish the raw edge.

Loose Casters

Typically, a furniture caster is made with a shaft that fits into a tube-shaped socket. The baseplate of the socket has sharp teeth that secure the socket to the furniture leg. It's not unusual for the teeth to relax their bite. When this happens, the socket and caster fall out.

Fastening the socket so that it will stay put takes just a few minutes. Remove the socket and coat the outside with epoxy putty. There are many good brands available, but I've had excellent results with Devcon Plastic Steel. Don't get any epoxy at the top end of the socket; it may interfere with the tip of the shaft. After tapping the socket back into the hole, lightly grease the shaft, especially the tip, and drive it into the socket. From time to time, as the epoxy cures, turn the shaft to make certain that it is not being held by the epoxy. Ordinarily, simply greasing the shaft will prevent any epoxy from accidentally adhering.

If you don't have any epoxy handy, you can make a temporary repair by winding steel wool or plastic tape around the socket to make it fit in the hole more tightly.

Damaged Molding

When the damage is extensive and the molding is a standard pattern, you can save a great deal of time and trouble by simply replacing the bad section with a new length purchased from your local lumber dealer.

If identical molding isn't available, you might consider removing all the old molding and replacing it with another pattern.

Chances are, however, that only a small area is damaged. In that case, either Plastic Wood or Water Putty can be used

If suitable replacement molding is not available, a router may be rented at little cost so that you can make your own molding.

to fill the broken area. For this purpose Water Putty is preferable because it doesn't shrink as it dries. In fact, if care is taken while applying the putty, it can be shaped with a palette knife until it accurately matches the form of the molding. After the patch has dried, it should be smoothed with very fine sandpaper. It may then be finished to match the rest of the piece.

If preferred, instead of using a patching material, the damaged area can be cut out and replaced with a piece of wood chosen for similar grain. After gluing in the new wood, allow ample time for the glue to dry. The inset piece can then be shaped with a small carving chisel or knife.

Broken Turnings

Unless you have a supply of wood on hand that will allow you to select a piece that closely matches the grain and color of the broken part, you'll probably find it better to repair rather than replace a member having only minor damage.

A small split can be repaired by simply prying it open far enough so that glue can be applied. The repair should be well clamped until it has dried. For badly split stretchers and similar parts where the damage is close to the end of the member, a glue-and-dowel repair is recommended. Drill through the split with a bit one size larger than the dowel. Cut a dowel peg short enough so that when driven into the hole, it will be slightly below the surface. Then form glue-holding grooves by squeezing the dowel with pliers having sharply serrated jaws. Apply glue to the split and the dowel; tap the dowel into place and clamp the assembly until dry. The hole can be hidden by filling with Plastic Wood or stick shellac.

If the member is broken completely in two, a glue-and-dowel repair can also be used, but instead of cross drilling through the split, each piece is end drilled. For accurate alignment, drive a

brad almost all the way into one end of the break. Make certain that the brad is exactly centered. Then press the other broken end against the head of the brad so that the wood is marked. After removing the brad, use a drill bit one size larger than the dowel peg to bore a hole through both marks. Apply glue to both broken ends and to the dowel grooved as already explained. Assemble the two pieces with the dowel joining them and clamp until dry.

Some repairs may make it necessary to partially disassemble a piece. In the winter, placing the piece to be repaired close to a radiator or heating register will dry out the glue, shrink the wood, and make dismantling easier. In summer, putting the piece in a hot, dry attic will achieve the same result. Several days may be needed for the joints to loosen sufficiently.

When a part is so badly damaged that it must be replaced, you may have to use some ingenuity to find a suitable piece of wood with which to make the new part. Most small lumber-yards don't stock fine hardwoods, and even when they do, it's new lumber. What's really needed is old wood that will blend into the rest of the piece for an inconspicuous repair. The source of such wood may be anything from a broken baseball bat to a discarded chest of drawers. As long as the grain and color of the wood match closely, that's all that matters.

Chair-Caning

If you have chairs with broken caning in their seats or backs, you can put them in new condition without spending a great deal of time or money. Even if you've never done any caning, you'll find that the work isn't at all difficult. The secret is to use ready-woven caning; it is available in different widths, lengths, and weave patterns.

A wedgelike wood strip called a spline, fitted into a groove

brad almost all the way into one end of the break. Make cer-
tain that the brad is exactly centered. Then press the other
broken end against the head of the brad so that the wood is

When a part is badly broken it's best to make a new piece rather
than to try to repair the old one. Here, a new chair leg is being
sanded to shape.

A wedgelike wood strip called a spline, fits

around the edges of the seat cutout, is used to fasten the caning. The old spline must be carefully removed to avoid damaging the groove. You may find that the glue has deteriorated enough so that the spline can be pried out. If not, lay wet strips of cloth over the spline and leave them there a day or two to soften the glue. Don't forget to rewet the cloth from time to time. After the glue has softened, work the point of an awl or very small screwdriver under the spline and pry it out.

The new caning must be soaked in warm water until well softened. After it is installed, it will shrink as it dries for a tight, neat fit. If the replacement spline is of the one-piece type that must be bent completely around the seat cutout, it should also be soaked so that it will be pliable enough to install without cracking.

Once the old spline has been removed and the groove brushed clean, make accurate measurements for a thin cardboard pattern to use in cutting the new caning. For a workmanlike job, the caning should be cut and installed so that its strips line up perfectly with the edges of the cutout.

With the tip of a screwdriver or other wedge-shaped tool, work the edges of the caning into the groove. Next apply glue to the splines. If the cutout is square, you'll need four splines; these should be mitered for the sake of appearance. Install the front spline first, then the rear, and finally, the side splines. To avoid damaging the splines, tap them into place with a wooden or plastic mallet. Complete the job by using a single-edge razor blade to trim any strands of caning that protrude from underneath the splines.

Rush-Weaving

Weaving a rush seat is the sort of job that appears much more complicated than it actually is. Traditionally, cattails and similar marsh plants were the main sources of this material, but

fiber cord is now more often used. Though made of paper, it is strong and looks enough like natural rush to fool anyone but an expert.

Fiber cord makes the work considerably easier because it doesn't require the lengthy soaking and wringing that natural rush needs. There are other advantages: There's no bothersome twisting to join strands together, and splices can be kept to a minimum because fiber cord comes in long, continuous rolls. It's a standard item at most handicraft supply houses and is generally available in various colors and three diameters: $\frac{1}{8}''$, $\frac{5}{32}''$, and $\frac{3}{16}''$. A three-pound roll of $\frac{3}{16}''$ fiber cord will give you more than enough to do the seat of a typical Early American ladder-back chair.

The standard weave that produces the distinctive four V-shaped sections is done like this:

Start by tacking the cord under the right end of the back rail. From there pass the cord over and under the front rail, then over and under the right-side rail. Next, pass it over and under the left-side rail, then over and under the front rail. Continue by passing the cord over and under the back rail, then over and

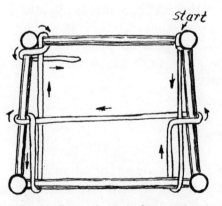

Start of standard rush-weaving

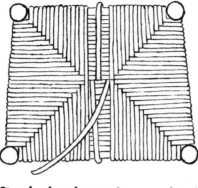

Standard rush-weaving completed

under the left-side rail. Repeat the pattern until the side rails are full. The space that remains on the front and rear rails is filled by running cord over and under these rails, pulling it through the center each time. The end of the cord is then tacked or tied securely to the back rail.

You're probably thinking that because most chairs have irregularly shaped seats, wider at the front than at the back, simply following this pattern will leave an opening in the middle that can't be woven. You're absolutely right! Here's what you do: Pencil-mark a measurement on the front rail equal to the length of the rear rail. Both marks must be the same distance from the front corners.

Before working the regular pattern, weave short lengths of fiber cord around the front corners until you have reached the pencil marks. By doing this short weaving you'll change the irregular opening to a rectangular one that can be woven closed using the standard pattern.

Short weaving is started by tacking one end of the cord to the inside of the left-side rail near the front corner. Next the cord is passed over and under the front rail, then over and under

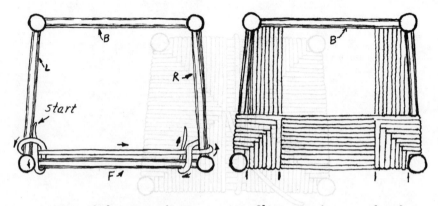

Start of short weaving **Short weaving completed**

the left-side rail. It continues over and under the right-side rail, then over and under the front rail. The free end of the cord is tacked to the inside of the right-side rail. After the short weaving has reached the pencil marks, the standard pattern can be started.

You'll find that fiber cord is easier to work if you dip it in water as you use it. Soaking isn't advisable; just wet the cord briefly.

To minimize splices, work with as long a length of cord as you can conveniently handle. If you wind the cord around a dowel, you won't have any difficulty working with long pieces. To splice, simply tie the cord ends together, or glue them and then bind the joint with a wrapping of string. Any splices that you make should be done so that they are on the underside of the seat.

For a professional-looking job, be sure that the weaving is kept properly squared as you work. It's easy to inadvertently allow a cord to run over an adjoining strand. Good weaving technique also requires that each strand be pulled up snugly. Muscle isn't recommended for this; instead, just try to pull as uniformly as possible each time.

If you'd like the seat to have a full appearance, you can stuff excelsior or torn-up newspaper in as you weave. After you've finished, protect your handiwork by brushing the top and bottom of the seat with three coats of clear shellac.

Overhauling Outdoor Furniture

A lawn chair or table is often discarded when only a simple repair would have put the piece back in service.

For a thorough refurbishing job on aluminum furniture, begin by brightening the surface with fine steel wool. Wipe clean with solvent, then apply an automobile paste wax and buff with a clean cloth.

When repairs are needed, they can be made quickly and neatly with a tool such as the Pop Riveter. To avoid the corrosive reaction of dissimilar metals, use aluminum rivets. Choose a rivet length at least ⅛" greater than the thickness of the work. Nuts and bolts or self-tapping screws can be used instead if preferred.

Pop Riveter is handy for repair of aluminum or wrought-iron furniture.

Glue Gun loads with a quick-setting adhesive that is ideal for repairing broken wrappings on rattan furniture.

The plastic webbing commonly used on aluminum chairs and lounges is available in a variety of colors and widths if replacement is necessary. For an inconspicuous repair, attach the replacement webbing with the same type of fasteners originally used. Most often these are self-tapping screws with washers.

Wooden lawn furniture may have cracks or other weak points that can be beefed up with metal mending plates or angle irons. When attached with screws underneath the damaged piece, repairs made in this way are hardly noticeable. If a chair arm or leg is badly split, don't waste time trying to salvage it. Instead, remove the broken piece and use it to make an accurate pattern. Outline the pattern on a suitable piece of lumber and cut with a saber saw or coping saw. Whatever finish is to be applied should be put on before attaching the new part, so that the entire piece can be coated for complete protection against rot and dampness.

Wooden lawn chairs often develop loose arms. If turning in the screws all the way doesn't help, extract the screws and fill the holes with Plastic Wood. When this has hardened, reinstall the screws.

Ordinarily, repair of rattan furniture is a tricky job because of the problems involved in clamping after applying adhesive. The problem can be overcome by using an electric glue gun loaded with a rapid-bonding cartridge of polyethylene-base glue. The gun is a snap to use: Just touch the nozzle to the torn end of rattan. Press the rattan in place. In one minute the glue will form a durable, waterproof bond.

Refinishing
Old Furniture

Removing Old Finishes

✿✿✿✿✿✿✿✿✿✿✿✿✿✿✿✿✿✿✿✿✿✿✿✿✿✿✿✿✿✿✿✿✿✿✿✿ Removing the old finish from a piece of furniture is like washing a stack of greasy dishes or digging a hole—it's no fun at all. It takes perspiration and perseverance. But it can be satisfying work when your efforts uncover fine, richly grained wood under the mask of paint and varnish.

In planning your attack, you can choose any of three methods: mechanical, thermal, or chemical. Mechanical removal involves scraping or sanding. It works well on tabletops and other flat surfaces, but there are serious drawbacks. For one thing, the coarse sandpaper needed for fast finish-removal will scratch the surface so badly that a lot of finish sanding will be necessary. And for another, if you're refinishing an old piece, the patina—that mellow color that comes with age—will be sanded off along with the old finish.

On the other hand, mechanical removal is economical. It's neat, too, particularly if you're using a sander fitted with a dust-collector bag. The type of sander used is important. Most common is a simple sanding disc chucked in an electric drill. This is an effective tool, but its cross-grain motion will leave a badly scratched surface. A far better choice is a belt sander or other machine having a straight-line action so that it is possible to sand with the grain.

Personally, I have never been able to work up much en-

34

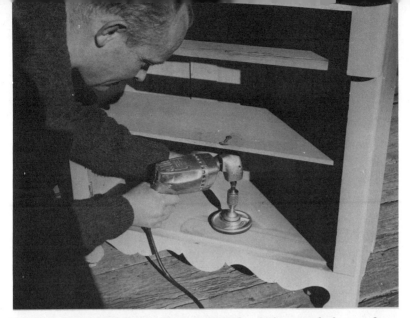

Removing the old finish with a sanding disc is fast work, but surface is scratched because of cross-grain action.

thusiasm over scraping furniture, but if you're determined to scrape, I recommend that you use pieces of broken window glass about 3″ to 4″ long. These are easier to use than regular scraping tools and when dull cost nothing to replace. Store-bought scrapers do nasty things like gouging out hard-to-fix valleys. Unless you're a virtuoso, steer clear of scrapers.

Burning off the old finish is usually done with a propane torch equipped with a flattened burner tip called a flame spreader. The usual method is to hold the torch in one hand and a putty knife or scraper in the other. The torch is slowly but continuously moved while the scraping tool follows along to remove the softened, blistered paint. Like using a belt sander and coarse paper, using a torch for finish removal is undeniably effective, but it is also very risky. The chances of accidentally starting a fire are excellent because it is so easy for hot embers to drop unnoticed onto wood shavings or sawdust, where they may smolder for hours before bursting into flame. Precautions are obvious: Keep the work area free of any combustible materials, have a garden hose or at least a bucket of water at hand, and examine the work thoroughly before you walk away to be sure that no embers remain.

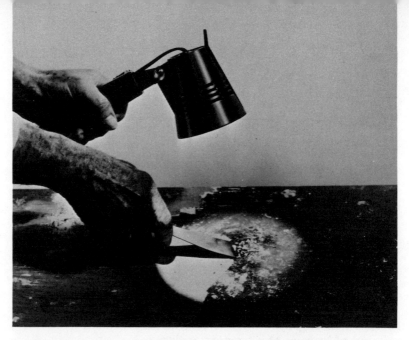

Torch-Lamp uses an electric lamp to soften old finish so that it can be scraped away.

If the fire hazard isn't enough to dissuade you, I might point out another problem: Unless you keep the torch moving constantly, you're apt to scorch the wood. Once you've done that, you're in for big trouble. As far as I'm concerned, burning off paint is more suited to barns and battleships than to fine furniture.

There are times, though, when heat may be the easiest, fastest way to remove an old finish. This is especially true when you're working on a piece that has many layers of old, hardened paint. If you decide that burning off the old finish is the best approach, I strongly recommend the use of an electric paint-removing tool such as the Smith-Victor Torchlamp. Because the tool uses an electric lamp as a heat source, rather than an open flame, the fire hazard is minimized.

Of the three ways to strip an old finish, chemical paint removers generally work best. Though they're called paint removers, don't let the name fool you; they're not at all fussy and will also do a fine job of varnish removal. They are made in various formulas by dozens of manufacturers, but they work in basically similar ways. Paint removers do their job by soften-

ing the old finish so that it can be washed off or scraped away.

It takes time for the remover to work, and its main ingredient, the solvent, is continuously evaporating. Of course, the faster the rate of evaporation, the slower the remover works. To minimize this problem, removers also contain a wax that acts as an air barrier and so reduces evaporation. The extremely volatile ingredients used in most removers pose a great fire hazard, so some manufacturers add methylene chloride, which makes the mixture nonflammable.

Now that you've patiently read this short course in chemistry, you're ready to shop for a paint remover. As you walk down the paint-store aisle, probably the first thing you'll wonder about is the great difference in paint-remover prices. Some may cost twice as much as others. Which should you buy? Generally, the more costly removers are the better choice. You'll notice when reading labels that nearly all the removers marked "nonflammable" cost more than the others. That's because they contain extra ingredients such as the methylene chloride already mentioned.

The higher-priced removers are also easier to use. Most are labeled "wash-off" or "water-wash." This means just what it says—no scraping is needed. It's merely a matter of rinsing off the surface with water after going over it with a wet scrub brush. Less costly removers contain stubborn waxes that must be thoroughly removed with solvent before applying any finishing coat. If the wax is allowed to remain, the finish probably will not adhere properly and may never dry completely. So all things considered, the higher-priced removers usually turn out to be bargains in the long run.

Speaking of bargains brings up the subject of low-price substitutes for commercial paint remover. Although it's fairly common practice to use lye as a remover, it's so highly caustic that it just isn't worth the risk. And even if you're lucky enough not to slosh any on yourself, you'll find that lye doesn't have a

very happy effect on furniture. It often produces discoloration and can even weaken the wood fibers.

Before using any paint remover, read the manufacturer's instructions completely to find out what precautions are necessary. The most common recommendation is that you work in a "well-ventilated" place. If the remover contains benzol or any other equally unfriendly toxic solvent, I recommend that it be used only outdoors. If you must work indoors, set yourself up near an open window, and take frequent breaks for fresh air. It's also a good idea, because removers may cause skin irritation, to wear rubber gloves and a long-sleeved shirt. If you should accidentally get any remover on your skin or even on your clothing, wash it off promptly.

The first step is to remove hinges, drawer pulls, and all other hardware. It's well worth the extra time to take these off before starting, rather than attempting to work around them when

Newspapers and masking tape protect drawer interior from unintentional application of paint remover.

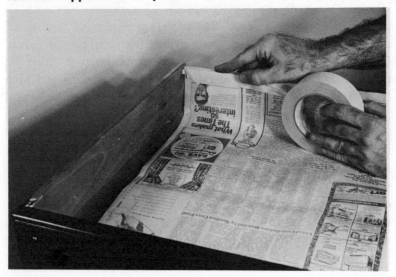

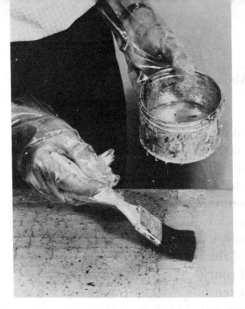

Apply paint remover liberally with an old brush.

applying paint remover. Any surfaces that are not to be refinished should be covered to protect them from paint remover. Use newspapers and masking tape on the interiors of drawers and doors to protect them from spattered remover.

If you're working indoors, cut up some corrugated cartons and protect the floor with at least one thickness of cardboard. Then add several layers of newspaper. Newspapers alone may soak through, allowing the remover to damage flooring.

When weather permits, you'll probably choose to work outdoors. Pick a spot out of the sun, because high temperatures cause the solvents to evaporate rapidly, thus reducing the remover's effectiveness.

To minimize run-off when applying the remover, turn the piece when necessary so that whenever possible you can work on a horizontal surface. If the work cannot be turned and there are large vertical surfaces, as on built-in cabinets and similar pieces, a paste-type remover should be used. Removers of this type are heavy-bodied enough to stay in place even on vertical surfaces.

Paint remover should be applied generously. In fact, a fine way to apply it is to simply pour it on. Or you can put it on with an old brush. If you use a brush, just lay it on with a

single stroke if possible. Don't brush it out like paint, because the thinner the layer, the more quickly it will evaporate, and the brushing action itself will introduce air into the remover.

You'll probably adopt a method of working that seems convenient to you, but as a start, you might like to try it my way. I limit my work to small areas at a time—three or four square feet. How long it will take for the remover to work depends upon how old the finish is, how many layers there are, temperature, and of course the specific remover being used. Generally, I wait about ten minutes after the finish has started to soften before I begin scraping. If the piece has a painted surface, a positive indication that you can start scraping is wrinkling of the paint. The clue to begin work on a piece with a clear finish is the forming of sludge, indicating that the remover has penetrated.

The basic idea, of course, is to do the scraping before the remover begins to dry. With a broad-blade scraper I try gently to remove the softened finish. If it doesn't come off easily, I wait and try again a few minutes later.

Then I use the scraper to take off whatever material I can. Whenever the surface seems to be drying, I apply more remover. The process is repeated until the finish is completely off. As a final step, the manufacturer of the remover may recommend wiping with a neutralizer such as denatured alcohol. Be sure to follow such instructions.

The scraper or other tool used to lift the softened material should have a dull blade. Its edge must be free of burrs and its corners rounded so that it won't scratch wood surfaces that have been softened by remover. Brand-new scrapers and putty knives have corners that are too sharp for safe removal work and should be blunted with a file.

By far the safest tool to use is a homemade scraper. Maple or other hardwood is an ideal material for such a tool. Make it about 8" long with a wedge-shaped blade. Use a sharp knife and rasp to form the other end into a comfortably rounded handle.

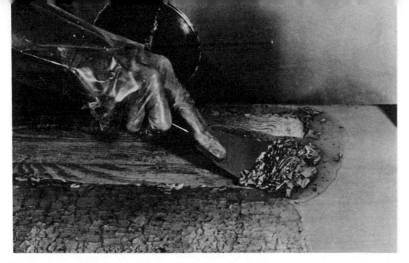

Easy removal is assured if paint is allowed to wrinkle completely before scraping begins.

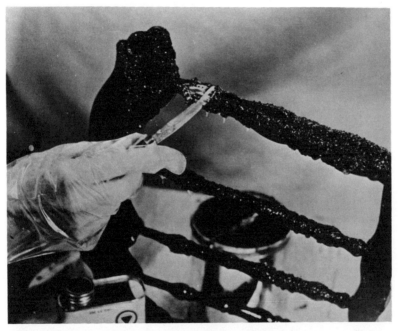

When scraping softened paint from turnings, care is needed to avoid gouging the wood.

To avoid damaging surfaces, round corners of scraper blade with a fine file.

Clean out grooves with an orange stick.

If you're removing the finish from turned legs, carved surfaces, or grooves, a scraper alone will not do the job. An orange stick makes a fine picking tool for probing grooves. For cleaning out carvings, try a small soft brush; don't use a stiff wire brush—its bristles will scratch the wood. On turnings, a wad of steel wool works very well.

On antiques, or for that matter, any really valuable pieces, it's best to forget scrapers entirely. Instead, use fine steel wool or a piece of burlap to wipe the softened finish. You'll need patience to do this, but it's the only sure way to avoid surface scratches.

(Left) **Remove paint from grooved surfaces with a small brush.** *(Right)* **For valuable or delicate pieces wipe off softened paint with a coarse rag.**

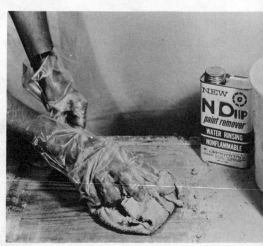

Wash-off removers are applied the same manner as the scrape-away types, but after the finish has softened sufficiently, it's only necessary to go over the surface with a scrub brush or steel wool before washing with water. Afterward, the wood should be wiped thoroughly and allowed to dry completely. Drying may take as long as two days.

My preference is for the wash-off removers because they're so easy to use. Unfortunately they're not always suitable. For example, when you're removing the finish from a veneered piece, rinsing it with water may soften the glue and cause the veneer to buckle. Even on pieces that are not veneered, it's important to restrain your enthusiasm when hosing off the remover. Excessive application of water increases the chances of staining the wood or raising the grain. This can lead to considerable extra work.

After stripping the finish, examine the surface to be sure that you're done a complete job. Look for dried remover in carvings and corners. You may even find traces of the old finish in grooves and turnings. For a thorough cleanup, use whatever tool seems most convenient. Anything from a kitchen knife to a rasp may be required to get rid of the last bits of old finish.

To complete the job, use turpentine and clean rags to wipe down the surface. You can also use any of several chemical cleaners intended for this purpose. This final wiping is more important than it may seem. By thoroughly cleaning the surface, you'll make sanding easier.

Sanders and Sanding Techniques

After you've removed the old finish and really begun to look things over critically, you're certain to make all sorts of unpleasant discoveries. There may be loose joints, holes, scratches, perhaps even a broken rung or cracked door. If these or any

As a final step, some manufacturers recommend wiping surface with a chemical cleaner.

other repairs are needed, they should be made before sanding. If you reverse the procedure and sand before you fix, you may find yourself doing a lot of extra work that really could have been avoided. Suppose, for example, there's a joint that needs gluing. The right way to do the job is to fix the joint, then sand the entire piece. In so doing you'll automatically remove any dried glue that happened to squeeze out of the joint or dribble on another surface. If, on the other hand, you sanded the piece before repair, you'd wind up duplicating your effort in order to remove the glue.

For detailed information on repair materials and techniques, see Section 1, "Repairing Furniture Surfaces, Joints, and Parts."

Once the repairs have been made, you're ready to start sanding. Having done considerable sanding myself, both with muscle and motor, I can report authoritatively that hand sanding is a

Flat surface such as this is ideal candidate for power sanding, but legs and other turnings require hand sanding.

waste of valuable time and energy. So unless you're an exercise nut, buy, borrow, or rent a power sander. There are four basic types to choose from:

Disc Sander. The simplest tool of this sort is an electric drill equipped with a rubber disc and a circle of abrasive paper. Such tools work rapidly but are suitable only for rough work because their rotating action creates deep scratches. For all practical purposes, a disc sander's greatest value in furniture work is not for sanding but for polishing, when fitted with a sheepskin buffing pad placed over the disc.

Orbital Sander. The abrasive sheet on this tool is attached to a vibrating plate which moves with a tiny circular motion. The result is that the sanding action at one instant is across the grain, then with the grain. Because some of the sanding is cross-grain, scratches are produced. With very fine abrasives, the scratches produced are minute, but nevertheless they can be easily seen. For this reason, the orbital sander, though it is a fast, useful smoothing tool, is not the best choice for furniture work.

Straight-Line Sander. Like the orbital sander, the straight-line model uses a sheet of abrasive fastened to a vibrating platen. The important difference is that the platen moves back and forth so that sanding is done as it should be—with the grain. For producing the smoothest possible surfaces the straight-line sander is ideal. It's a slower-working tool than the orbital sander, but it's possible to have your cake and eat it too: If you're impatient, you can do the initial sanding with a straight-line sander held at an angle to the grain. Though this would not meet the approval of a master craftsman, it does speed things along. Then you can follow up by sanding with the grain. Some manufacturers offer sanders with a selector switch that allows the user to choose either straight-line or orbital sanding.

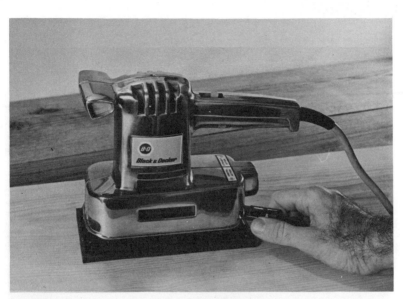

This sander offers orbital action with switch in this position.

Same sander can be switched to straight-line action.

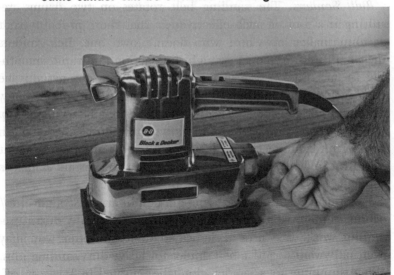

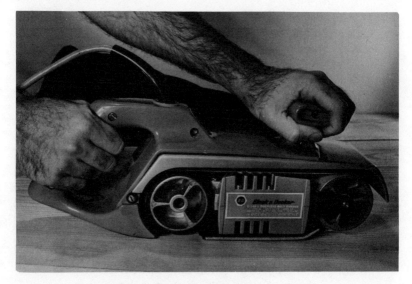

Belt sander is best for heavy use.

Belt Sanders. The sanding belt rotates on two drums, resulting in a tool of such effectiveness that there probably isn't a cabinetmaker anywhere who doesn't own one. Belt sanders meet both requirements: straight-line action and rapid smoothing. In fact, they're so eager to work that they can actually be used not only for sanding but for planing and forming. They can trim too-tight doors or round the edges of a heavy plank-top table. Because they work so rapidly, they must be used with care. If, for example, the sander is switched on and then brought down to the work, it will bite out a crater the instant it makes contact.

To sum it all up, if you choose a combination straight-line/ orbital sander, you'll be able to handle most any furniture-sanding work. If you're a dedicated do-it-yourselfer, you may eventually want to add a belt sander for heavy-duty sanding jobs. When shopping for a sander, don't be tempted by low-cost, off-

brand vibrator models. These are too puny for anything but very light sanding. Instead, look for a man-sized, heavy-duty tool made by one of the major manufacturers. This will not only assure you of quality but also eliminate any problems if you should ever need service or repair parts. Don't buy any sander that can't be fitted with a dust bag or hooked to a vacuum cleaner to suck sanding dust away, and, as with any other portable power tool, be sure that the tool has a ground wire to protect you from possible electrical shock.

Whether you do your sanding by power or hand, it's important to know what abrasives are available and how they differ. There is always an ideal abrasive for the job at hand; it's only a matter of knowing what's needed. In fact, if you were to jot down all the different types made for both industrial and do-it-yourself applications, the list would run into the thousands. But for our purposes, we can whittle that number down considerably. Shopping for sandpaper really involves only four considerations: type of abrasive, backing, grit spacing, and grade.

Walk into a hardware store, ask for "sandpaper," and almost always you'll be given flint paper. It's the kind with the familiar tan paper backing. You've probably used it dozens of times if only because it is so widely available. Though it costs less than other abrasives, it is also far less efficient. It loads up rapidly, cuts slowly, and isn't worth using, except for paint removal or where cost is a major factor. Compared to other abrasives, flint paper is primitive stuff—a sort of twentieth-century version of the ancient Chinese abrasive made by gluing ground-up seashells to parchment.

If there's such a thing as "a bargain at even twice the price," it's garnet paper. It costs two or three times as much as flint paper but is such a workhorse that it's well worth the extra money. It is made with a much more durable paper backing than is used for flint paper. As you might expect, garnet paper

has a reddish grit. Most expert craftsmen consider it best for finish sanding.

Aluminum oxide is a brownish, synthetic abrasive manufactured with a cloth or paper backing. It performs much the same as garnet paper but is even longer lasting. More commonly available than garnet, aluminum-oxide paper is excellent for both hand and power sanding. The cloth-backed version is especially durable. Use it for power sanding wood or metal.

A highly specialized paper is silicon carbide. If you've ever watched the proceedings in an auto paint shop, you've probably noticed this abrasive being used. It's black, with a flexible, waterproof paper backing, and is often used for wet sanding primer or lacquer.

Sandpaper backings of paper or cloth are made in different weights. The paper stocks used are 40, 60, 70, 90, 100, 110, and 130 pounds. Each is based on the weight of 480 sheets measuring 24″ by 36″. Weights are designated by the letters A, C, D, and E. The 60- and 110-pound papers have no letter marking.

A-weight, known as finishing paper, is 40-pound stock. It is intended for light-duty work such as finish sanding where a thin, soft backing is necessary to minimize the danger of scratching the work surface.

C- and D-weights are called cabinet papers. For rugged sanding jobs, the D-weight is recommended. It is made of 100-pound stock and is significantly more durable than the 70-pound C-weight backing. Both C- and D-weights are suitable for hand and power sanding.

E-weight papers, of 130-pound stock, are intended for the most severe use and are made primarily for power sanding.

Cloth backings made from cotton fabrics are commonly available in either X- or J-weights. The X backing contains heavier threads than the J and is a better choice for power sanding. The J-weight comes into its own for sanding curves and irregular surfaces that demand a pliable backing.

A flexible backing is a must for sanding turned work.

Sandpapers differ in another important respect: The way that the grit is spaced on the backing determines whether the sandpaper is classed as "closed-coat" or "open-coat." Closed-coat papers are made so that the surface is covered with grit as completely as possible. On open-coat papers, the grit occupies only 50 to 70 percent of the surface.

Open-coat abrasive papers have spaces between the grit particles to reduce clogging.

Closed-coat abrasives work best on steel and other hard materials that don't tend to clog the grit and reduce its cutting ability. But when clogging is a problem, as in sanding wood or painted surfaces, an open-coat paper is superior. The spacing between grit particles prevents cuttings from being trapped and filling the paper. For this reason, though there is less grit on a sheet of open-cut paper, it lasts longer and can often do a more effective job than a closed-coat abrasive. For most do-it-yourself fur-

niture-sanding work, open-coat papers should be used. Only garnet and aluminum-oxide papers are made in closed- and open-coat types. Flint paper is not described as being either open-coat or closed-coat.

You can buy sandpaper in any of twenty-two different grits. The abrasive particles range from nearly BB-shot size to a powder so fine that sandpaper manufacturers refer to it as "flour." There are three systems used to specify sandpaper grade:

Mesh, or Grit, Number. This number describes the system for determining all abrasive grain sizes. The mesh number is based on the number of openings per linear inch in a standard grit-measuring screen used by all manufacturers. For instance, 100-grit sandpaper compares to an industrial screen having 100 openings per inch. The coarsest grit has a mesh number of 12; the finest has a mesh number of 600.

Symbol. This is a purely arbitrary system that covers nineteen of the twenty-two grain sizes emcompassed by the mesh numbers. The coarsest paper (mesh number 12) bears the symbol number $4\frac{1}{2}$. The finest paper on the symbol scale is 10/0—the same as mesh number 400.

Simplified Marking. Most of us think of sandpapers as being very fine or very coarse. This is not as precise a system as using mesh numbers, but it is easy to understand, and for most purposes it's accurate enough. Thus some manufacturers designate sandpaper grade by using what they call the simplified marking system—seven grades ranging from extra coarse (mesh number 30) paper to super fine (mesh number 400).

Flint papers are usually stamped according to the simplified marking system. Aluminum-oxide papers are marked with mesh numbers or mesh and symbol numbers. Garnet papers customarily bear both mesh and symbol numbers.

For really smooth surfaces you'll need 220-grit paper or finer. Once you get past 240, you may run into difficulty finding dealers who stock the finer grades. If a hardware store or lumber-

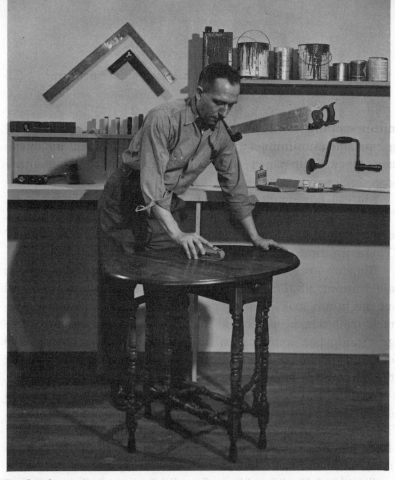

For finish sanding you will need very fine sandpaper and a delicate touch.

yard doesn't have what you need, try a supplier who caters to professional users. A cabinetmaker or piano refinisher should be able to help you find such a dealer.

More often than not, you'll do best to begin sanding with a 3/0 paper. Papers coarser than this are intended more for shaping than surface smoothing. Whenever possible, the paper should be backed up by a sanding block. This will assure not only a smooth surface but a perfectly true one. Paper used without a block will actually cut ridges and valleys in the work because wood is composed of both hard and soft areas.

It's handy to have a set of sanding blocks made in different sizes so that you can choose a convenient one for the job at hand. You can buy ready-made blocks or make your own, as I do. The size I find best is 1½″ by 3″ by 4⅜″. A standard sheet of aluminum-oxide or garnet paper is enough to make six pieces for this block.

To make the block easy to grasp, gouge out a finger groove on each side. Pad the face of the block with felt glued in place. An unpadded block may do more harm than good: The paper will tend to clog because of the heat generated by friction, and if wood particles become caught between the paper and the hard, unpadded face of the block, there is a great danger of scratching the very surface you are trying to smooth.

A ready-made sanding block of ideal proportions is a ski waxing cork. You can buy one at almost any sporting-goods shop. Pad the cork with felt before using it.

Save dowels and old tool handles to make sanding blocks for special jobs. A felt or rubber pad should be contact-cemented to the wood to cushion the surface.

For sanding a tabletop or similar surface, you'll need a flat block, of course, but for sanding moldings or curves, the sanding block can be made from a dowel, broomstick, or anything else that conforms to the shape of the surface being sanded. In tight, awkward spots back up the sandpaper with a piece of cardboard.

(Left) On curved surface, sanding block can't be used; instead, fold sandpaper or back it with cardboard. *(Right)* Neat trick for keeping end of board square when smoothing end grain is to clamp on scrap strips to provide greater bearing surface for sanding block.

When sanding, try to work uniformly, or finishing materials may be absorbed unevenly.

Good sanding techniques demands uniformity. If you sand lightly in one place and heavily in another, finishing materials, particularly stain, may not be absorbed evenly. It's important also to brush the surface frequently to remove sanding dust. A power sander equipped with a dust collector does this automatically. In any case, sanding dust allowed to remain on the work tends to clog the paper and may even be forced into the surface of the wood, where it may later cause finishing problems.

After you've done the initial fine sanding with 3/0 paper, you can work your way up 6/0 or 8/0 paper. Just how far you

carry things depends upon the wood itself and the type of finish that you intend to use. The harder the wood, the more sense it makes to use extra-fine papers. For softwoods, 6/0 is the finest paper that need be used. And if you're planning to paint the surface, there's no need for anything finer than 4/0 paper.

For really fussy work, dampen the wood surface with water to raise the grain. The moisture will force the wood fibers to stand up; if you run your fingers over the surface, you may be surprised to discover just how rough the supposedly smooth surface has become. The wetting and sanding should be continued until the grain no longer raises when water is applied.

The smoothest possible surfaces are attained by applying a sanding sealer before doing the finish sanding. Such sealers are commercially available, or you can mix shellac with 4 parts of alcohol and brush it on. One caution: When using sanding sealers on surfaces that will later be finished with stain, test the sealer on scrap stock first. A sealer limits penetration (and therefore the color) of stain, so to determine if the color will be what you want, apply sealer to a scrap of the same wood, then apply stain.

Sandpapers aren't the only abrasives useful in furniture work. Steel wool is excellent for smoothing carvings and other difficult surfaces and is also good for brightening metals and other hardware. Automobile compound is often used for rubbing down finished surfaces. Pumice is a time-honored abrasive used to smooth a final coat. It is available in four different grades. The finest is 4/0; the coarsest is 0. Either water or oil can be used with pumice to make a rubbing paste. Though sometimes classed as an abrasive, rottenstone is only a polishing agent and should be used after a surface has been rubbed with pumice.

Finishes and Finishing Techniques

Modern finishing materials have reached a state of near-perfection. They're practically foolproof if you follow manufac-

turers' instructions carefully. Sometimes, however, a small error can stand in the path of a fine finish. To avoid such a pitfall it's important to know the characteristics of paints, varnishes, stains, and lacquers. There are vital differences in the surface preparation required, the brushes or spray equipment used, and the solvents and thinners needed for each finish.

Enamel. A painted finish has many virtues. When applied to a surface that has been patched with Plastic Wood or Water Putty, its opaque quality makes the repairs invisible. For the same reason, enamel is an excellent choice for finishing furniture that has an unattractive grain pattern or unsightly knots. One of the great advantages in using enamel for refinishing is that so long as the old finish is sound, paint removal is unnecessary. However, old finishes that are cracked or peeling must be completely stripped.

Enamels are made in gloss and semigloss types. Some manufacturers label semigloss enamel "satin finish." There are also flat enamels, but these lack the durability required for a furniture finish. The flat finishes are best used for picture frames and other items that won't be subjected to heavy handling or hard use.

An enamel is composed of a varnish base and a pigment added to provide color. As pigment content increases, durability decreases. For this reason, very dark colors in satin finishes are not a good choice for furniture finishing. If both a satin finish and a dark color are required, it's best to apply a high-gloss enamel and then rub it down when dry to the sheen desired. The rubbing involves a fair amount of extra work, of course, so you might consider using both a satin-finish and a high-gloss enamel in a single job. For instance, if you were going to paint a table, you would use a high-gloss enamel on the top. On the legs and any other underparts where durability was not as important as on the top, you would save time and effort by using satin-finish enamel.

If you're planning on enameling over an old finish that is

secure, simply washing the piece down with detergent and sanding lightly will properly prepare the surface. A surface conditioner such as Liquid Sandpaper might be used instead. This is applied with a cloth to remove old polish, wax, and grease. It also dulls the surface and ordinarily makes preliminary sanding unnecessary.

Enamel is such a hard finish that it is rather brittle and sometimes tends to chip. To minimize this, sharp edges and corners should be rounded very slightly with fine sandpaper before painting.

Use a rag soaked in turpentine to wipe the piece free of dust, then seal the surface with a 50-50 mixture of shellac and denatured alcohol. On old furniture that has been finished with a dark stain, this will prevent the stain from bleeding through the new finish. On new work, the shellac and alcohol are necessary to seal the grain. Afterward, smooth the surface with 4/0 steel wool. Wipe the surface clean, then apply an enamel undercoat.

Because an undercoat is normally white, the finish coat may not cover it adequately, especially on a single-coat job. To overcome this problem, mix 1 part of finish-color enamel with 3 parts of undercoat. This must be thoroughly mixed before use.

Actually, there isn't complete agreement on the use of an undercoat. Some manufacturers recommend using an undercoat but many recognized authorities suggest instead that thinned enamel itself be substituted for a specially formulated undercoat. My own feeling is that commercial undercoats are worth using, but you may want to try both methods to determine your own preferences.

Undercoat is heavy-bodied and should be brushed out well. Because this will be the foundation for your finish, special care should be taken to assure smooth application. Be wary of runs and sags; brush them out before they set.

Be generous in allowing time for the undercoat to dry. The minimum is twenty-four hours, but humidity can easily double the drying time required. When dry, smooth with 4/0 sandpaper used with a felt-padded sanding block. Only light sanding will be needed. After that, wipe away all dust.

For a professional finish, brush the enamel over a small area, using with-the-grain strokes. Then cross-brush, working at a right angle to the original strokes. This will level the paint perfectly. Finally, with the brush held perpendicular to the surface, stroke gently with the grain, using only the very ends of the bristles. This is called tipping off.

Though one coat may be acceptable for some purposes, two coats will add both appearance and durability. If you are going to apply a second coat, sand the surface lightly first for good bonding.

If you have used high-gloss enamel, you may want to rub down the surface. The procedure is the same as outlined in the section on varnishes.

Varnish. For furniture made of fine wood, the most desirable finish is a transparent one. Varnish is an excellent choice because it offers both depth and durability. The manufactured resins used in modern varnishes are the big reason why today's product is so improved over the old natural-resin varnishes.

Varnish cans are always labeled to indicate the type of resin contained: phenolic, alkyd, and urethane are the major ones. Varnishes made with any of these are excellent. Alkyd varnishes usually cost a little less but aren't as durable as urethanes. For outdoor use, phenolic varnishes have the edge. Urethanes seem to be truly clear; other varnishes verge on being yellow. All in all, I recommend urethanes; they have more than enough assets to offset their higher cost.

A varnish finish is only as good as the surface underneath it; new wood should be sanded with progressively finer grades of

Plenty of sanding with progressively finer grades of abrasive is needed for a professional-looking refinishing job.

sandpaper until it is glass-smooth. If you are going to refinish a piece, wipe it thoroughly with mineral spirits, then sand lightly so that the varnish will adhere properly.

Dust is the bugaboo of every finisher who works with varnish. Even tiny dust particles seem to grow once they land on the surface of the work. There's no way to absolutely eliminate the problem; dust is everywhere. But there are several precautions you can take that will help a great deal. Obviously, the major requirement is a clean place to work, one that is as dust-free as possible. The outdoors is a poor choice because there's not only considerable dust, but pollen and insects as well. The best bet is a room that no one will have to enter while the work is drying. If possible, avoid using a room with draperies or carpeting. In a pinch, you might even work in a large empty closet. If your workshop is like mine, with sawdust and shavings all over the place, don't even consider doing any varnishing in it. You could vacuum-clean it, of course, but you'd stir up so much dust in the process that you'd have to wait for hours before you could start varnishing. And even then you couldn't be sure that all the dust had settled.

Everything used for the job must be as clean and dust-free as the room itself. If the work is to be supported on sawhorses while it is being varnished, don't forget to clean them before use. Even your clothing should be carefully chosen. Fuzzy sweaters and wool shirts, in particular, should be avoided because they increase the chances of getting lint and dust on the work. If you can manage to dampen the floor, the dust problem will be considerably reduced.

Even under the cleanest conditions, dust still lands on the work surface. To remove these tiny particles just before varnishing, finishers use a tack rag. This is a cloth moistened with varnish, which makes it tacky enough to pick up dust when it is wiped over the work. You can buy a ready-made tack rag at any paint store, or you can easily make one. Soak an old cotton handkerchief in warm water, then wring it out well. Fold the

cloth and pour turpentine on it. Work the cloth to distribute the turpentine, then wring it once again. Sprinkle a tablespoon of varnish on the cloth; twist and fold the cloth several times to distribute the varnish completely. Continue working the cloth in this way until it is nearly dry. To keep the cloth just tacky enough, you'll have to sprinkle it occasionally with water and turpentine as you use it. When not in use, the rag should be kept in a clean can or jar with a tight lid. Before putting the rag away, sprinkle it with turpentine and water to keep it in good condition. To use the rag, fold it to a convenient size and wipe the work surface.

You'll need a 2″ varnish brush of good quality. A varnish pot, something no professional finisher would be without, is also necessary. Make one from a can or a discarded kitchen pan about 4″ in diameter. Punch two holes on opposite sides near the top for a strike wire, so that you can wipe excess varnish from the brush. In no case should you ever work from the varnish can itself. Doing so is not only awkward but also risky, because the bubbles and froth that tend to develop in the can may eventually find their way into the finish.

Brushwork plays a big part in determining the quality of the finish. On a panel, such as the end of a dresser, the first step is cutting-in: literally, outlining the area to be varnished. Begin at the corners and work inward to the center of the panel edges. After cutting-in, cross-brush, using against-the-grain strokes. Work from both sides inward to the middle of the surface, lifting the brush as the strokes meet to avoid piling up varnish in the center. Then, with a nearly dry brush, stroke lightly with the grain, from top and bottom inward to the center. These tipping-off strokes are crucial; hold the brush at a right angle to the surface and use the very tips of the bristles, so that the brush barely grazes the work. If possible, move the work so that you are able to apply the varnish to a horizontal surface to prevent runs.

(Left) **Good technique calls for brushing lightly from the center of the surface out toward the ends.** *(Right)* **Don't make the mistake of brushing from the end of the work to the center; this produces sags.**

The brushing technique varies a bit for surfaces such as table-tops. Here, the best method is brushing with the grain, from the center to the ends. The brush must be lifted at the instant the end is reached. This prevents varnish from accumulating on the edges. Don't make the common mistake of stroking from the end to the center. This invariably produces sags on the edges. Finish by tipping-off. Edges should be done with a brush small enough so that the bristles don't come in contact with the wet varnish on the top of the piece.

Table legs, chair spindles, and other turnings should be brushed across their width. When possible, follow with tipping-

(Left) **On edges, use a small brush for a neat job.** *(Right)* **On turnings, brush across the work rather than along its length.**

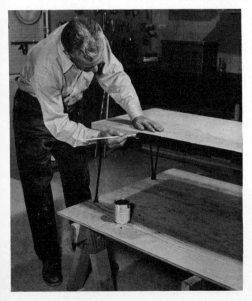
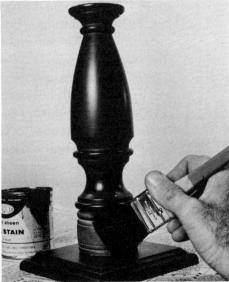

off strokes. On intricate turnings with many grooves and sharp edges, tipping-off should not be attempted.

The first coat of varnish should be thinned with about 1 part turpentine to 5 parts varnish. The mixture should be stirred thoroughly and prepared a day in advance to give the varnish time to absorb the turpentine. On subsequent coats, or when applying varnish over a shellac undercoat or penetrating oil stain, no thinning is needed.

It happens even under the best conditions that tiny dust particles appear in the wet varnish. At first, you'll have difficulty distinguishing dust specks from bubbles. Bubbles usually level out as the varnish dries, but dust must be removed immediately. Once the varnish begins to set, it's too late. If you're facing toward a window or other light, which good varnishing technique dictates, the bubbles will reflect light, making it easy to differentiate dust particles.

Dust may be lifted with a size 0 brush or a finely pointed piece of wood. Professional finishers make a special tool for the purpose, called a picking stick. You can do the same by heating powdered rosin until it melts. To avoid burning the rosin, it's best to put it in a container which in turn is placed in a pot of water. This improvised double boiler can then be safely heated. When the rosin has melted, mix 6 parts to 1 part varnish. To use, pick up a bit of the mixture with the end of a small stick. With moistened fingers roll this into a ball. Touch the ball lightly against the dust speck to be lifted. The varnish-rosin mixture will be sticky enough to pick off the dust. Each time you remove a dust particle, roll the ball with moistened fingers to work the speck in. A delicate touch is needed for dust picking. If the ball touches the surface, it will leave a mark.

After you've applied a coat of varnish, leave the work alone. Resist any temptation to brush over bad spots. Instead, wait for the varnish to dry, then sand and apply another coat. Drying time varies, of course; as long as two days may be necessary in humid weather. Most manufacturers specifically indicate

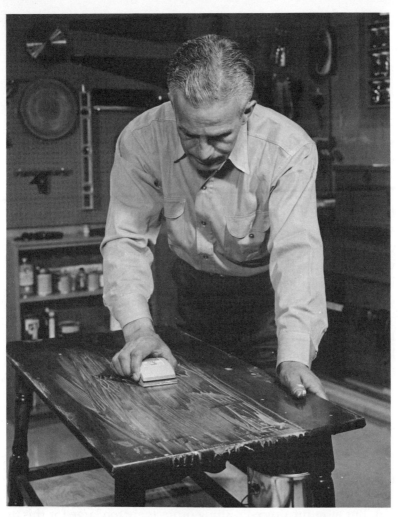

Wet-sanding is necessary to level the surface.

drying times on the instruction label. Incidentally, even if you're an old hand at finishing, you'll find it worthwhile to read such instructions. Varnishes differ greatly from one brand to another and there are times when special procedures must be followed.

To make a good varnish job perfect, it should be rubbed down. After the first coat has dried, sand lightly with the grain, using 5/0 garnet paper. Sanding should be done without using water for lubrication, and ideally the sandpaper should be slightly worn.

Subsequent coats should be wet-sanded with 6/0 garnet paper used with a sanding block. The sanding must be sufficient to

level the surface and dull it completely. After the final coat, rub with FF pumice and water, using a felt-padded block. When the entire surface has been dulled, wipe clean with water and rags.

The pumice-and-water rubbing levels the varnish and creates a perfect surface. But it's a dull, unattractive one. To restore luster, rub with rottenstone and water, using a felt pad. Rottenstone is not an abrasive; it's a polish, and the more you rub, the greater the luster. When the surface is to your liking, thoroughly wash off all traces of pumice, using water and clean rags. Follow by wiping with benzine for a complete cleanup. If desired, the surface may be waxed and buffed as a final touch.

Lacquer. Compared to other finishes, lacquer is largely neglected by the amateur finisher. There's a good reason for this lack of acceptance: Lacquer is more difficult to use than shellac or varnish.

The greatest problem stems directly from what is actually one of lacquer's best attributes: short drying time. Any worries about dust are virtually eliminated when using lacquer, because the material dries dust-free in less than fifteen minutes. But rapid drying also means that you have to work fast, sometimes uncomfortably fast, when brushing it on.

A solution is to apply lacquer by spraying, using an aerosol can. But most furniture-finishing projects are too large for this to be a workable method. Lacquer really comes into its own when used with a spray gun. In fact, special spraying lacquer that dries even more quickly than brushing lacquer is available. Either type may be used for spraying, but spraying lacquer cannot be applied with a brush.

Unfortunately, spraying with aerosol can or spray gun can lead to difficulties that may be baffling to a do-it-yourselfer. Once the causes of these problems are known, however, the remedies become obvious. For instance, if you spray too liberally, the lacquer will sag and run. Pinholes often result when a second coat is sprayed on too soon. Orange peel is the name used to de-

scribe the bumpy finish caused by too great a sprayer-to-surface distance.

Another virtue of lacquer that also gives rise to a problem is the solvent effect that lacquer has on paint and varnish. Lacquer even has a softening effect on itself; when lacquer is applied over another coat of lacquer, the preceding coat is softened just enough to assure proper bonding of the new coat. Obviously, in this case the solvent properties are advantageous, but when lacquering over paint, varnish, fillers, and some stains, the same properties make it necessary to go to the added effort of a shellac sealer before lacquering. If a sealer is not used, a painted or varnished finish must be stripped before lacquer is applied.

A brush larger than you would normally use is necessary so that you are able to work quickly. The cardinal principle is to flow the lacquer on with an absolute minimum of brush-work. Ideally, one long, swift stroke should be made with each brushful. You must work rapidly enough so that the edge of the last stroke is still wet when the next stroke is made. Strokes should overlap just enough to avoid what professional finishers call holidays: bare spots or ones inadequately covered. Runs and sags should be smoothed immediately with a single stroke. Once the lacquer begins to set, such defects can't be brushed out.

It's best to apply at least two coats, thinned in the ratio of 3 parts lacquer to 1 part lacquer thinner. But if you are planning on a one-coat job, thinning isn't recommended.

Though sanding isn't required for good bonding, sanding lightly between coats is necessary to smooth tiny defects. From four to eight hours drying time should be allowed before sanding, and no water or other lubricant should be used on the sandpaper.

When the final coat has dried, the surface can be rubbed to a satin finish with automotive rubbing compound. This is a highly abrasive material and must be used carefully. A safer

method, but a slower one, is to rub with pumice and oil, then polish with rottenstone and oil.

Shellac. Here's a finish that's tailor-made for the do-it-yourselfer. It involves none of the mysterious problems encountered when using lacquer or varnish, dries dust-free in less than thirty minutes, and brushes on easily. Its only real shortcoming is that it can be damaged by alcohol or water, but this deficiency can be largely overcome by keeping the finished surface well waxed.

Though a shellac finish requires at least two coats, only four hours have to be allowed between coats. This makes it possible to complete even a multicoat job in less than two days. Anyone who has been defeated when attempting to use a brushing lacquer will be happily surprised by shellac's easy application. With only moderate care in thinning and brushing, there are ordinarily no brush marks or other defects.

Usually it's wise to buy finishing materials in large-quantity containers because there is a considerable cash saving. But shellac has a relatively short shelf life and it's best to buy only as much as you have immediate need for. The problem has led some manufacturers to print expiration dates on their products. But unfortunately, this is not yet an industry-wide practice. If you must purchase an undated can, try to buy at a busy store where the turnover is enough to keep the stock fresh.

Shellac that you've had on hand for more than a few months should be tested on scrap before using it on an actual job. If it dries completely within a reasonable time, the shellac is safe to use. The drying time will likely be much longer than when the shellac was fresh.

You can buy white shellac, which is actually clear, or orange shellac. Your own preference, and the type of wood to be finished, will determine which is more suitable. On some fine hardwoods, orange shellac produces an especially handsome finish, but it's best to try both on scrap before making a choice.

Shellac is always thinned with alcohol before use. Experienced finishers sometimes estimate the proportions, but for most of us it's better to rely on measurement when cutting shellac.

When you buy shellac, the label will indicate the proportion of resin to alcohol. A 5-pound cut, for example, is manufactured in the proportion of 5 pounds of resin to 1 gallon of alcohol. Thinning shellac with denatured alcohol permits easier brushing and faster drying. For accurate cuts, follow these proportions:

PROPORTIONS FOR STANDARD SHELLAC CUTS

BASE CUT	NEEDED CUT	ALCOHOL PER QUART OF SHELLAC
5-pound	3-pound	$\frac{7}{8}$ pint
5-pound	2-pound	1 quart
5-pound	1-pound	$\frac{2}{3}$ gallon
4-pound	3-pound	$\frac{1}{2}$ pint
4-pound	2-pound	$\frac{3}{4}$ quart
4-pound	1-pound	2 quarts
3-pound	2-pound	$\frac{3}{4}$ pint
3-pound	1-pound	3 pints

Manufacturers recommend that a 3-pound cut be used in most situations. This is fine for an experienced finisher, but a beginner will have better results with a 1- or 2-pound cut. The thinner cuts dry more quickly, are easier to brush, and are more forgiving of poor technique.

Shellac should be flowed on in full, wet coats using with-the-grain strokes and a minimum of brushing. Sand between coats with an open-coat paper and a sanding block to level the surface. After the final coat, sand again, then rub with 4/0 steel wool to dull the surface. Protect the shellac with a coat or two of good paste wax buffed thoroughly.

Immediately after use, work excess shellac from your brush onto a pad of newspaper. Then soak in alcohol. When the job is completed, soak the brush in a solution of household ammonia and warm water. This will clean and condition the brush. The shellac can should be capped tightly and stored away from heat.

A classic furniture finish called French polishing can be applied by thinning white shellac to a 1-pound cut—shellac should reach a waterlike consistency. A soft, lintless cloth is then rolled into a ball and dipped into the shellac. The shellac is rubbed on the wood with fast, straight strokes and moderate pressure.

After the wood has dried, it should be sanded lightly with 6/0 paper. Apply more coats, sanding between each one, until a light glow appears. Then add several drops of boiled linseed oil or pure olive oil to the shellac mixture and continue application, but with a rotary motion. Add oil a little at a time with subsequent coats, until a deeply glowing finish is attained. This may require anywhere from eight to twelve coats.

Wood that is to be French polished must first be thoroughly sanded and then stained with a non–grain-raising product. Ample drying time should be allowed before French polishing.

Stain. Unlike enamel, varnish, or shellac, stain is never used as a final finishing coat. It provides almost no surface protection, since its single, vital function is to change the color of the wood.

Although there are other, specialized stains available, most projects can be handled with either a pigmented wiping stain, a water stain, or a non–grain-raising stain.

Pigmented wiping stains are the most common of the three. In fact, you can often buy them at dime stores. Water stains and non–grain-raising stains are tougher to find because they are usually sold only at supply houses catering to professionals. If you have difficulty finding these items, you might save a lot of bother by contacting one of the specialty suppliers listed in the back of the book.

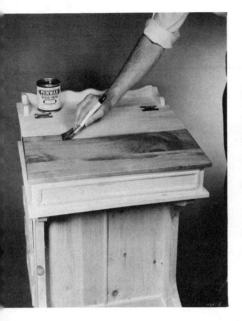

Minwax is a time-proved stain used by many finishers for a hand-rubbed effect. After brushing on the stain, it is wiped. When dry, a spray coat adds protection. Right photo shows completed project.

Some stains are supplied in containers having built-in applicators.

Pigmented stains are made by many manufacturers and are labeled in different ways. Most are not specifically marked "Pigmented Wiping Stain." They may simply be labeled "Wood Stain" or "Oil Stain." To further confuse matters, there are not only differences in labeling but also in packaging. Pigmented stains come in cans, tubes, and even containers with built-in applicators. Despite these differences, the composition is the same; the coloring matter is a pigment suspended in an oil-resin vehicle. As a result, the pigment has a tendency to settle to the bottom of the container unless it is frequently stirred. There are times when you can take advantage of this. By applying the stain without stirring, using just the vehicle, the work will be very lightly colored. For some woods this result may be more to your liking than if you had used the stain conventionally.

All types of stains are identified by wood names. Though a stain might be marked "Maple," it can, of course, be applied to any wood species. Unfortunately, it's not possible to transform pine, for example, into something even vaguely resembling a hardwood such as walnut simply by using walnut stain. Even if

the color is convincing, the grain and characteristic appearance of the woods are so different that the stain job will fool no one. On the other hand, there are some woods that respond well to this sort of trickery. Mostly, it's a matter of trial and error because stains, woods, and individual technique vary a great deal.

But the real reason for using a stain is to emphasize the beauty of wood by intensifying its color. Staining to make one wood resemble another is hardly ever necessary except perhaps when replacing a broken part with a different kind of wood.

Water stains are packaged in dry-powder form and must be dissolved in near-boiling water. This may seem a nuisance, but water stains cost only a fraction of the price of pigmented wiping stains. For some amateur finishers, so little stain will be purchased even over a period of years that such an economy may not be significant. But water stains have more to offer than just low price. Once the powder and water are mixed, no stirring is necessary while working, because the color is completely dissolved. This assures a consistency that may be lacking when using a pigmented stain that has inadvertently been allowed to settle. The absence of pigment permits water stains to color wood in a natural-looking way. They penetrate into the wood without leaving the surface film that pigmented stains do.

Non–grain-raising stains are sold in concentrated liquid form and are usually thinned before use with denatured alcohol or a special thinner. NGR stains contain little or no water, and so they do not roughen the surface by raising the grain, unlike the water stains. They dry much more quickly than water stains and are often favored by professional workers. A spray gun is best for applying NGR stains because their rapid drying makes it difficult to brush on an even coat.

When buying any stain, the wood name used by the manufacturer can give you nothing more than a vague idea about the actual color of the stain. Most stores have sample blocks on display showing various stain colors on different woods. But even

this won't tell you exactly what color will result when you use a certain stain on a particular wood; there are too many variables.

The best approach is to buy a stain color as close as possible to what is needed. This won't be difficult. The complete lack of agreement between different manufacturers as to what should be the exact color of each stain will give you a great number of choices. If one manufacturer's walnut stain, for example, is not quite the right shade, try some other brand. When you've finally found a stain that's about the right color, there are several ways to change the color until it's exactly what you want.

If a water stain is too light, darken it by adding black water stain. Similarly, NGR stain can be darkened with black NGR stain. Darken a pigmented stain with black pigment. It's readily obtainable in tubes at most paint stores.

Stains that are too dark can be lightened with an appropriate solvent. Water stain, for instance, can simply be diluted with a greater quantity of water than would normally be used.

Pigmented stains can be lightened considerably by wiping them soon after they are applied, rather than letting them penetrate. Though NGR and water stains can be lightened by wiping, they respond best to dilution when paler color is desired.

Another approach is to seal the wood with a wash coat of shellac before applying the stain. For this purpose. a ½-pound cut should be used; if you start with 3-pound–cut shellac, mix 4 parts of alcohol to 1 of shellac. By partially sealing the wood pores, the wash coat will prevent the stain from penetrating deeply, and color will be considerably lightened.

A prerequisite for any stain is clean, bare wood. With new wood there's no problem, but when refinishing furniture, the old finish must be stripped with paint remover before staining. Smooth sanding is crucial; any rough spots or scratches allowed to remain will be darkened by the stain and made very obvious.

After sanding, a wiping with lacquer thinner will assure a clean surface.

On finely made furniture, it's unlikely that there will be any exposed end grain. But on inexpensive pieces that are sold unfinished, simple butt-joint construction will reveal end grain. The tendency of end grain to soak up stain and become darker than the rest of the wood can be overcome by brushing with a shellac wash coat before staining. Care should be taken when applying the shellac to keep it off the face and edges of the work.

Pigmented stain may be applied with either a brush or lint-free cloth. Typically, manufacturers' instructions advise waiting several minutes for the stain to penetrate before wiping. But there's really no reason why wiping can't be done sooner if a lighter color is desired.

Applying pigmented stain isn't a fussy job. The technique is simplicity itself: Apply the stain across the grain; wipe with the grain. When wiping, the cloth should be refolded frequently so that you are always wiping with a clean surface.

When applying a water stain, turn the piece when possible to avoid having to work on vertical surfaces. This will help prevent drips and spots. The stain should be put on with the grain, using long, rapid strokes. Choice of brush is important; it should be large enough so that you can apply the stain evenly. If the brush is too small, you won't be able to work rapidly enough and each new stroke will be over a partially dried edge. The surface will then be badly streaked.

Any soft brush of suitable size is good for water stain. It must be perfectly clean. A rinse in turpentine followed by a washing in soap and water will do the job.

NGR stains may be applied with a brush, but spraying is far better. Brush application involves the same considerations as for water stain, except that NGR stain dries even more quickly and lap marks are a greater problem. Much of this trouble can be

avoided by mixing equal parts of stain and thinner. If the mixture is brushed on as evenly as possible and wiped quickly, lap marks will not form. Of course, using a diluted stain will prolong the job, but drying time is so short that three or four coats can be applied in one day.

After you've gained some experience with NGR stains, such generous thinning won't be required. You'll find that by using a wide brush, working quickly, and wiping almost immediately, applying an even finish won't be impossibly difficult. With either water stain or NGR stain, wiping is not a standard procedure as it is with pigmented stain. Wiping is necessary with pigmented stain to lighten color and remove the surface film that forms on the work. With water or NGR stains, wiping is simply an aid for the amateur who is concerned about applying a lap-free finish. An experienced finisher would usually not find it necessary to wipe an NGR or water stain to prevent lap marks.

After staining, a filler may be used to hide the pores of the wood and provide a perfectly level surface. Filling is the proper textbook technique that should follow staining. But you are the only one who can decide whether it's right for *your* project. Usually, coarse-grained woods such as oak are filled, and in some cases even fine-grained woods such as maple are filled. But the real concern is how to achieve the effect you want. If a natural-looking finish is what you're after, you might very well omit using a filler. On the other hand, if you are refinishing a mahogany piano or a formal dining-room table, you would almost invariably use a filler to produce the glasslike surface appropriate to work of this kind.

Filler is available in both paste and liquid types. Paste filler is better for most purposes. Its ingredients include silex, linseed oil, and a drier. Paste wood-filler is made in natural wood colors as well as in a cream color. The colored varieties are not stocked by most paint shops, although specialty suppliers usually have them. However, if you can find only cream-colored paste

filler, there's no problem, because colors in oil can be used for tinting.

Before using paste filler, thin it with turpentine or naphtha to a creamlike consistency. Then, if you're working with cream-colored filler, tint it slightly darker than the stained wood. Some experimentation may be in order; try different shades by varying the amount of color in oil used for tinting. After applying the filler over a stained area on the underside of the work, pick the shade you like best. Although filler is ordinarily used to hide wood grain, by tinting the filler much darker than the stained wood, you'll emphasize wood pores. In some cases, this may be highly desirable.

Thinning the filler doesn't call for any special skill, but there are some tricks that will make the job easier. For a start, empty the filler into a large, wide-mouth container that will give you plenty of mixing room. Then use a putty knife to break up lumps of filler before adding turpentine or naphtha. Either of these thinners should be added a little at a time and accompanied by thorough mixing.

One pint of thinned filler will cover about thirty-five square feet; use this figure to determine how much filler to mix. Try to prepare only as much filler as you will actually need because the mixture will thicken after a few hours. This can be varied slightly by your choice of thinner. Naphtha will cause the filler to set more quickly than will turpentine. Experienced finishers sometimes use both naphtha and turpentine in a mixture to achieve a certain setting time. Greater changes in setting time can be made by adding boiled linseed oil as a retardant, or to speed things along, a drier can be added.

Different woods require filler mixes of various consistencies. The information in the chart indicates the mixes usually required. Though the words "thin," "medium," and "thick" are used to describe the filler consistencies, they are nothing more than relative terms. Even thick filler should be of proper consistency for brushing.

FILLER MIXTURE FOR VARIOUS WOODS

No FILLER NEEDED	THIN FILLER	MEDIUM FILLER	THICK FILLER
Basswood	Alder	Butternut	Ash
Cedar, red	Beech	Elm	Chestnut
Cedar, white	Birch	Kelobra	Hickory
Cypress	Boxwood	Korina	Locust
Fir	Cherry	Lacewood	Oak, red
Holly	Cottonwood	Mahogany	Oak, white
Magnolia	Gum, black	Orientalwood	Padouk
Pine, white	Gum, red	Primavera	Philippine
Pine, yellow	Maple, hard	Rosewood	mahogany
Poplar	Maple, soft	Walnut	Teak
Spruce	Redwood	Zebrawood	
Willow	Sycamore		

PROPORTIONS FOR MIXING FILLER

THICK MIX (16-pound base)

AMOUNT REQUIRED (Approx.)	PASTE	THINNER
½ pint	½ pound	4 ounces
1 pint	¾ pound	6 ounces
1 quart	1½ pounds	12 ounces
2 quarts	2¾ pounds	22 ounces
2½ quarts	3½ pounds	28 ounces
3 quarts	4¼ pounds	34 ounces
4 quarts	5½ pounds	44 ounces

MEDIUM MIX (12-pound base)

AMOUNT REQUIRED (Approx.)	PASTE	THINNER
½ pint	½ pound	5 ounces
1 pint	¾ pound	8 ounces
1 quart	1¼ pounds	13 ounces
2 quarts	2½ pounds	27 ounces
2½ quarts	3 pounds	32 ounces
3 quarts	3¾ pounds	40 ounces
4 quarts	5 pounds	53 ounces

THIN MIX (8-pound base)

AMOUNT REQUIRED (Approx.)	PASTE	THINNER
½ pint	¼ pound	4 ounces
1 pint	½ pound	8 ounces
1 quart	1 pound	16 ounces
2 quarts	2 pounds	32 ounces
2½ quarts	2½ pounds	40 ounces
3 quarts	3 pounds	48 ounces
4 quarts	4 pounds	64 ounces

Note: Fillers, like other finishing products, vary to some extent, depending upon the manufacturer. If there is a discrepancy between proportions given in the chart and any that may be recommended by the manufacturer of a particular filler being used, manufacturer's recommendations should be followed.

Finishers are not in agreement about the necessity of sealing the stain before applying filler. But aside from the slight amount of extra effort involved, sealing with a shellac wash coat is a wise precaution. Sealer will eliminate the possibility that solvents in the final coat may dissolve the stain and cause color to bleed through. And to a great extent, the time spent in sealing will be saved when filling; filler applied over a coat of sealer is far easier to wipe.

The controversy about sealing extends to filler sealers as well. Here, too, a topcoat may contain solvents capable of softening the filler; there seems to be no reason for tempting fate by omitting the sealer.

For light finishes, a wash coat of white shellac is usually used; over dark stains, orange shellac is more suitable. A sealer that dries more quickly than a standard shellac wash coat and is easier to apply can be made by combining lacquer with the thinned shellac. If you're going to mix a stain sealer, thin 3-pound–cut shellac with alcohol, 7 to 1. Proportions for a filler sealer are 4 to 1. After combining the shellac and alcohol, pour gently into an equal quantity of mixing lacquer.

A stiff, short-bristled brush is best for applying filler. Brush the filler on with the grain; use plenty and be certain to cover the entire surface. Then work the filler in with cross-grain strokes. When you see dull spots forming, that's a signal to start wiping. You can save a lot of work by going over the surface just before you wipe with a broad-blade scraping knife. Make all strokes acress the grain and wipe the scraper often to remove filler. Follow this by cross-grain rubbing with burlap or some other rough, heavy cloth. Remove every bit of filler that you can, but don't be tempted to rub with the grain; that would remove filler from the pores. All that is necessary is to remove excess filler.

If you wait too long before wiping, you're apt to find that the filler resists your efforts. Moistening the wiping cloth with

naphtha will make your work easier. You'll also be able to save some elbow grease by filling and wiping in sections so that the filler doesn't set before you've finished wiping. For hard-to-get-at spots in carvings and moldings, a picking stick or scrub brush may be needed to remove excess filler. In any case, do a thorough wiping job, or you'll run the risk of winding up with a streaked finish.

Brushes and Brushing Techniques

There are times when you can get by with the poorest brush imaginable. Brushing on paste filler, for example, or applying a wiping stain aren't the sort of jobs that require a high-quality brush. But for really fine work with lacquer, shellac, varnish, and enamel, a good brush is an absolute necessity.

At first glance, one brush may look pretty much like any other. The similarity vanishes when you take a closer look. Brushes differ in some very obvious ways: width, bristle length, type of bristle, and handle shape. And there are other differences, subtle ones, that are perhaps even more significant.

In the good old days, the finest, most expensive brushes were made of hog bristle imported from China. You can still buy natural-bristle brushes, but they're likely to be more horse than hog. Softer brushes, needed for varnish and shellac work, also have gone through a change. They used to be made of fitch (European polecat) hair; now they're made from sable, goat, badger, or skunk bristles. But the biggest development in brush-making was the nylon bristle. It took time for nylon brushes to gain acceptance; now, even professional finishers prefer them.

Nylon bristles not only perform as well as natural ones but also bear an amazing resemblance. In fact, you may have to read the manufacturer's label to be certain that the bristles really are man-made.

When buying a brush, whether nylon or natural bristle, here's what you should look for:

The filling of the brush near the ferrule should be rather stiff and there should be enough material so that the brush feels substantial at that point. Squeezing several brushes of different makes will give you a good idea of how much filling material is needed. You needn't wory about the possibility of too many bristles; no manufacturer is likely to waste material. But skimpy brushes should be avoided no matter how attractively they may be priced; they hold so little paint that you'll do more dipping than brushing. Even if you're patient enough to endure such inconvenience, you'll find that a brush with inadequate bristles won't let you apply a smooth finish.

All the bristles should be tapered. It's far less expensive to produce brushes with mixtures of tapered and blunt bristles, hence, many manufacturers offer 100 percent tapered bristles only in their more costly brushes—which demonstrates the point that with brushes, as with most other tools, you get exactly what you pay for. With a brush having tapered bristles and good body at the heel, near the ferrule, you're assured of maximum painting efficiency. To test a paintbrush for these characteristics, make a typical painting stroke on a tabletop or other flat surface, then stop the brush while still applying normal painting pressure. A brush without enough butt stiffness and bristle flexibility will usually "break" along the middle and will be a sloppy painting tool. The bristles in a properly made brush will curve uniformly from heel to tip when tested in this way.

The bristles on a good brush are "flagged," or split at the tips, so that they form tiny forks. Even on the best brush not every bristle will be flagged, but the more split tips the better. They make it easier to apply a smooth finish and vastly increase the brush's paint-holding ability.

You'll have to look closely for split ends; hold the brush against a strong light to silhouette the bristles. Separate the

bristles into small groups and make a mental note of the approximate percentage of flagged ends. Do the same with two or three other brushes made by other manufacturers. It's likely that one of them will have substantially more flags than the others. This sort of comparison is important because there is no fixed percentage of flagged ends absolutely required. It's simply a matter of picking a brush with a generous number of flags, assuming, of course, that the other tests are passed.

Checking for flagged ends will give you a chance to make another test at the same time. As you bend the bristles to separate them, they should have a definite springy action. If not, find another brush.

Any well-made brush tapers to a chisel edge so that the very tips of most of the bristles will touch the surface when the brush is held in a normal stroking position. It's easy to tell if the brush has the right shape if you sight across the edge from one end.

When you've found a brush that can pass these tests, you can be sure that it's a good one. But before parting with your money, make certain that the ferrule is tightly secured and that the handle provides a comfortable grip.

Over a period of time, you'll probably buy brushes in different shapes and sizes to suit certain jobs. For a start, buy a good-quality 2½" to 3" sash brush; with it, you'll be able to handle most finishing work.

Before using a new brush, work it across your fingers to remove grit and loose bristles. Then place the handle between your palms and twirl the brush rapidly to spin out any remaining loose material.

Some finishers condition a new brush by soaking it overnight in linseed oil. A brush treated this way should be suspended so that the tips of the bristles don't rest on the bottom of the container. Synthetic brushes or those to be used with shellac or lacquer should not be treated in linseed oil. Instead, they need

(Left) Twirl a new brush between your palms to get rid of loose bristles. **(Right)** Good work requires a relaxed grip; hold brush just as you would a pencil.

only a washing in warm, soapy water and a combing with a hair comb to smooth the bristles.

Before using a brush that has been linseed oil–treated, all unabsorbed oil must be removed by working the brush on a clean, flat surface or by squeezing the bristles between two dowels. Twirling the brush will remove some of the oil that remains, but for a thorough job, the brush should be dipped in turpentine for a minute or two. After that, the brush should be twirled and combed. To make certain that no traces of linseed oil remain, dip the brush in the paint you're going to use, and make several strokes on a clean surface before starting to paint.

Even if you haven't done much painting, attention to a few of the basics will enable you to paint like a pro. First of all, dip the brush no more than half the length of the bristles, then tap the brush against the inside of the can to remove excess

paint. The easiest way to work with any finishing material is to use a wide-mouthed container fitted with a strike wire across the top of the can for removing excess material.

Don't be timid—work with a full brushload; a good brush has surprising capacity when used properly. Your stroke should always begin on an unfinished part of the surface and extend to the wet area on the previous stroke. With fast-drying materials, a wide brush and rapid stroking are necessary to keep a wet edge and avoid lap marks.

To prevent sags and runs, it's best whenever possible to apply the material to a horizontal surface. This is no problem with small pieces that can be turned when necessary, but heavy or permanently installed furniture may involve finishing vertical surfaces. These should be stroked vertically to flow on the material, then lightly cross-brushed with a nearly dry brush for uniform coverage.

An almost-dry brush is also needed when applying a finish to a carved surface or an intricately contoured molding. Inside corners, such as in cabinets or bookcases, are another place requiring a very lightly loaded brush. Though it may seem convenient, don't use the side of the brush for painting corners, or anywhere else for that matter; it may damage the bristles. Instead, use a narrower brush.

There may be times when you have to tilt the brush upward, but this should be avoided whenever possible. Paint may flow into the heel of the brush, where it will eventually harden and swell the ferrule. Also taboo is stirring the material with your brush; ask your paint dealer for a stirring stick.

You can leave your brush in the container if you decide to stop briefly. A wire through the brush handle will suspend the bristles so that the flag tips are not damaged. If you're stopping for an hour or more, wrap the brush in aluminum foil; a tight wrapping is necessary to exclude air. There are commercial preparations available which may be used if desired. These

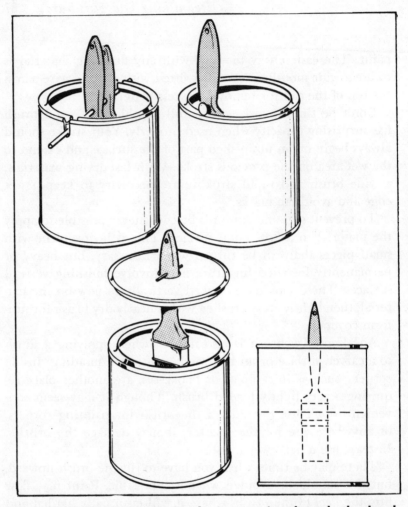

To *temporarily* store paintbrush, insert wire through the brush handle and suspend brush in container of solvent. Bristles must not touch the bottom.

contain special chemicals to prevent the brush from hardening. When you go back to work, you simply wipe off the antihardener, which is a sort of jelly, and the brush is ready for use.

When stopping work for several hours or even a few days, you can avoid the bother of cleaning the brush before the job is

finished. All you have to do is suspend the brush in a container of turpentine.

With the job complete, your brush should be cleaned immediately. A varnish or enamel brush can be cleaned with mineral spirits. Turpentine will also work, but it's much more expensive. Gasoline is an effective solvent and a cheap one, but it isn't worth the risk. Don't use it. A brush that has been used with shellac cleans easily with warm water and ammonia, or you can use alcohol. For a lacquer brush, use lacquer thinner. This comes in various qualities; for cleaning, the cheapest thinner you can get will be fine.

After you've run the brush through one of these solvents, a wash in warm water and a bit of detergent is recommended. Then you simply hang the brush until it dries, comb the bristles, and wrap in heavy paper.

To store brush longer than an hour, wrap it tightly in aluminum foil.

Spray Painting

Contrary to what most amateur finishers believe, spray painting isn't terribly difficult. In fact, after an hour or so of practice, almost anyone will be able to apply a better finish with a spray gun than he could with a brush. Not only is a sprayed finish smoother than a brushed one, but it is also faster to apply. Even a novice can spray five times as fast as he can brush.

There's a wide variety of spray equipment on the market, ranging from the very basic to special heavy-duty industrial units. The simplest spray gun is one that you might already own—a spray attachment for use with a vacuum cleaner. On small work, with well-thinned finishing material, it can do a good job. Next in the lineup is the vibrator spray gun. It is a low-cost, self-contained unit which, like the vacuum attachment, is intended only for light duty.

The least expensive spray outfit that can handle fair-sized jobs is one powered by a $\frac{1}{4}$-horsepower motor driving a diaphragm-type air compressor. Units of this type are specifically intended for home use; they are lightweight and simple to maintain. Often, the motor and compressor are housed together under a convenient carrying handle. The diaphragm keeps the air oil-free and has a life of eight hundred to one thousand hours. When it wears out, replacement is an easy do-it-yourself job and the cost of the diaphragm is negligible.

For heavier use, a piston-type compressor and a $\frac{1}{3}$-horsepower or larger motor are needed. Compressors of this type have pistons, rings, crankcase, and valves, just as in an automobile engine, and have a high air output. Regardless of type, compressors are rated by the amount of air they are capable of delivering and by pressure. The amount of air is measured in cubic feet per minute, abbreviated cfm. This is an important specification because it governs the amount of paint that can be sprayed each minute. The greater the cfm, the faster you can paint.

The pressure is specified in pounds per square inch (psi); a high-pressure unit lets you spray heavy paints and other materials without requiring a great deal of thinner. For furniture work, in which mostly stains, varnishes, and lacquer will be used, very high pressure won't often be needed. But a compressor able to deliver at least 35 psi of pressure will come in handy for heavy enamels and will enable you to finish a job with one coat, rather than the two or three coats required with a smaller compressor.

Spray guns also differ; there are two types: bleeder and nonbleeder. Bleeder guns are used with compressors that are continuously operating. The gun constantly "bleeds" air through its nozzle, even when not actually emitting paint. Nonbleeder guns are intended for use only with an air-pressure tank. The trigger of a nonbleeder gun controls both air and spray material. Air flow begins as soon as the trigger is squeezed; slight additional trigger pressure opens the spray-material valve. In general, nonbleeder guns are most often used with more elaborate spray outfits than are needed for occasional or light-duty work. In any case, the gun must be matched to the rest of the system. If a bleeder-type gun is used with a tank, the continuous flow, or bleeding, of air will quickly empty the tank. On the other hand, a nonbleeder gun hooked directly to a compressor will not permit relief of air-pressure buildup.

Feeding paint to the nozzle is achieved in either of two ways. In a pressure-feed gun an airtight container is used. Air pressure directed against the surface of the paint forces it up through a tube and out the nozzle. In a siphon-feed gun, air blowing across the top of a siphon tube causes a partial vacuum. A vent hole in the cover of the container permits atmospheric pressure to force the paint up the tube into the airstream. Pressure-feed guns can spray heavy material such as house paint; siphon-feed guns are limited to thin finishing materials. Ordinarily, any material thin enough for brushing can be sprayed with a pressure-feed gun. Siphon-feed guns require special spray-

Siphon-feed spray gun (left) and pressure-feed spray gun (right)

consistency material; however, ordinary brushing materials may be used in a siphon gun if they are well thinned.

Spray-gun nozzles are made in two different types: internal mix and external mix. Internal-mix nozzles combine air and paint inside the nozzle and are best suited to heavy, slow-drying materials. External-mix nozzles pass the air and the spray ma-

terial separately and mix them just as they leave the nozzle. This type is best for light-bodied materials, such as shellacs and lacquers, because of the fine atomization that the system provides. Internal-mix nozzles must be used only with pressure-feed guns; external-mix nozzles may be used with either pressure- or siphon-feed guns.

For furniture-finishing, your best choice would probably be a siphon-feed gun equipped with an external-mix nozzle. But if you're planning to use the gun for more ambitious jobs as well, involving heavy finishing materials, you'll need a pressure-feed gun.

External-mix spray-gun nozzle (left) and internal-mix spray-gun nozzle (right)

Before buying a spray outfit, you might want to rent one to see how you like it. Many paint stores and lumberyards have rentals for just a few dollars a day.

Successful spray painting requires that one master a few basic skills: stroking, control of spraying distance, and triggering. Proper stroking may be difficult at first if you've done much brush painting—the two movements are completely unalike. Anyone who uses a brush correctly tends to work with an arcing motion. If you do this with a spray gun, the nozzle will be too close to the work at the center of the stroke and you will wind up with too much paint in the middle and too little at each end. To avoid this difficulty, try to keep the gun about a hand's length away from the work throughout the entire stroke. Once you've gotten in the habit of moving the gun parallel to the surface, you will be well on your way toward becoming a good spray painter.

One thing that simplifies learning how to spray is that the causes of mistakes are always obvious and thus easy to correct. For example, if the paint runs, you'll know that the gun is being held too close to the work. Move the gun back too far, and you'll immediately be tipped off by both poor paint coverage and dusty or foggy appearance of the painted surface.

Triggering should be done in a consistent way, in rhythm with each stroke. Begin spraying an instant before the gun reaches the work and continue spraying as you follow through at the end of the stroke. Don't be hesitant about squeezing the trigger; pull it back as far as it will go. Indecisive triggering is sure to produce a blotchy finish.

For your practice efforts, there's nothing better than some empty cardboard cartons. These will give you a realistic workout because you'll have to contend with horizontal surfaces, vertical surfaces, and corners—just as you would in furniture-finishing.

Spray guns have only two adjustment knobs; turning one

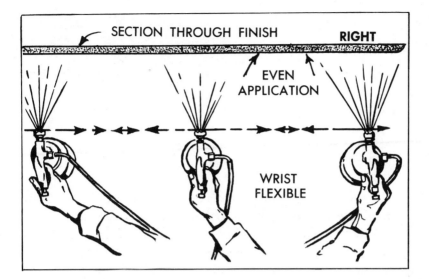

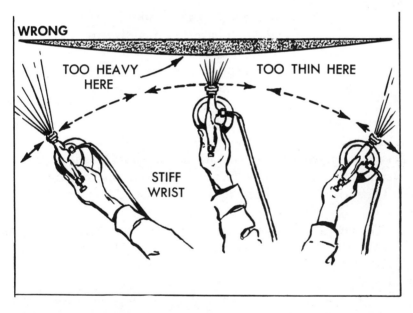

The wrist and elbow should never be held stiffly when painting with a spray gun.

varies the spray from a round pattern to a wide fan. The fan is best for broad surfaces; on small work requiring accurate control, the round pattern is preferable. The other adjustment knob regulates spray quantity. If paint is piling up and forcing you to stroke more rapidly than is comfortable, turn the knob to reduce the flow. When coverage is poor, the knob can be adjusted to increase flow of material.

If you run into problems, make certain that you are stroking and triggering correctly, and that you move the spray gun at a constant speed.

Properly overlapping previous strokes is something that gives first-time spray painters a lot of trouble. If you aim the center of the pattern along the edge of the previous stroke, you'll automatically overlap by about 50 percent, which is just right. Omit the overlapping, and you'll have an unsightly surface composed of alternating bands of paint and bare wood.

Once you have the technique perfected, you will be ready for work. If you have some outdoor furniture in need of spraying, this will be a good first project. Wicker or rattan furniture is particularly suited to spray painting, as is perforated metal lawn furniture. Use a four-hour enamel; don't make the common mistake of spraying furniture with house paint. It will chalk and come off on the clothing or skin of anyone using the furniture. The surface preparation required is the same as for brush painting.

When painting long, narrow vertical panels, it is best to stroke vertically, with the nozzle adjusted for a horizontal pattern. On panels requiring horizontal stroking, adjust the nozzle for a vertical pattern.

Broad horizontal surfaces, such as tabletops, are easiest to do if the gun is held at a 45-degree angle and the edges and corners are sprayed first. Then the top can be done, starting at the edge nearest you. Any overspray will land ahead of the gun and will be covered over as you complete the top. Reversing this system

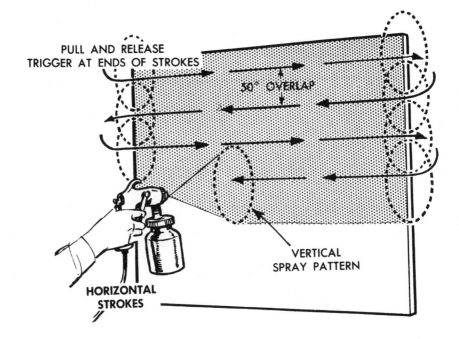

PULL AND RELEASE
TRIGGER AT ENDS OF STROKES

50° OVERLAP

VERTICAL
SPRAY PATTERN

HORIZONTAL
STROKES

Horizontal and vertical strokes with a spray gun

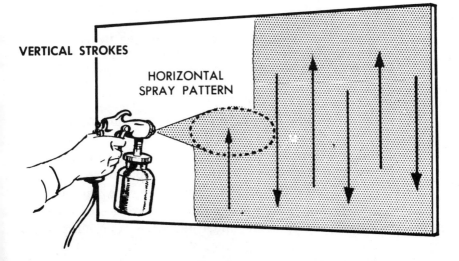

VERTICAL STROKES

HORIZONTAL
SPRAY PATTERN

Two methods of spraying inside corners. In A, gun is aimed into corner. This method is suitable for most work. In B, gun is held at 90-degree angle to each surface. This method gives more uniform coverage.

will permit overspray to settle on parts of the surface already finished and cause a rough finish.

Spraying a cabinet or bookcase involves some special techniques. For non-fussy work you can simply spray directly into the corner and paint both surfaces at the same time. On critical work, however, you'll do a better job by spraying each corner piece separately. To spray the undersides of shelves you'll prob-

ably have to angle the gun upward rather sharply; the cup shouldn't be more than half full to keep the contents from reaching the cover. If the gun doesn't feed properly when held at an angle, turn the fluid tube so that it is well submerged in the spray material.

Angle gun for spraying undersides and critical areas. In A, half-full gun is held at 60-degree angle. In B, gun is held at 90-degree angle to get paint on cup cover. In C, the position of the fluid tube is changed to keep it submerged. In D, tilting of gun is avoided with angle nozzle.

¾" x 6" LUMBER

BOLT AS
PIVOT

SWIVEL PLATE CASTER

Turntables are very helpful when spraying pieces; they are easily constructed out of inexpensive materials.

If you plan to spray a number of pieces, it will be worth-while to build a turntable for your work. The design shown is nothing more than a suggestion; any platform which you can easily improvise that will let you turn the work when necessary will be adequate.

You're not likely to have any baffling problems with spray equipment if you follow a methodical procedure when working. But just in case you have to do some troubleshooting, here's what you'll need to know:

A spray pattern heavy at one end is usually caused by a par-

tially clogged nozzle; remove the orifice and clean it with an appropriate solvent for the material being sprayed. A peanut-shaped pattern, small at the center and flaring at both ends, also calls for a nozzle cleanup. A heavy center pattern can be cured by increasing air pressure or thinning the spray material. Crescent patterns may be caused by a clogged nozzle; if cleaning doesn't help, the nozzle is probably damaged and should be replaced.

Orange peeling, so called because the surface is textured like an orange skin, is fairly common when spraying lacquer which has not been thinned enough; too much air pressure may also cause this defect.

Sags are positive indications that you are either laying on a too-generous coat, or that the spray material is too thin.

Streaks may stem from either a clogged nozzle or poor overlapping technique. A surface that looks and feels like fine sandpaper is also the result of poor spray-gun handling. It can be avoided by applying a sufficiently wet coat and always working from near side to far side in order to keep the overspray off the just-painted area.

An erratic spray may be caused by a loose fluid-supply tube. Or, if you're angling the gun, the tube may be out of the spray material. A siphon-feed gun may sputter if the material is too thick, or if the vent hole in the cover of the paint cup is clogged.

A dripping spray-nozzle can be fixed by cleaning the valve needle so that it can seat properly. Keeping spray equipment clean is very important. If a filter, for example, is clogged, the spray gun may be completely inoperative. It's also a good idea to strain all finishing materials; an old nylon stocking is ideal for this purpose. By doing this, you remove undissolved particles and foreign matter that might otherwise clog the gun.

Cleaning a gun after you've finished spraying is a snap—if you do it right away. If you wait and let the material harden, cleaning will be more work than you bargained for.

To clean a suction-feed gun, unscrew the paint cup, then press your fingers over the nozzle or use a rag. Squeeze the trigger to force material out of the supply tube back into the cup. After that, place the supply tube in a container of solvent and squeeze the trigger several times.

Empty the paint cup and wipe it clean with a solvent-soaked rag; do an especially thorough job on the threads of the cup and cover. Wipe the supply tube with a clean rag and solvent. Never immerse the gun in solvent; this will wash off important lubrication and may damage valve packing.

Cleaning procedure for a pressure-feed gun is the same. However, the container of solvent must be tightly screwed into the cover. Don't risk using glass jars of solvent when spray cleaning a pressure-feed gun—the pressure may be great enough to explode them.

Most of the techniques used in painting with a spray gun work equally well when painting with aerosol-spray cans. For small jobs, even if you have a spray outfit, you'll probably find it more convenient to use aerosols.

For a smooth finish, it is essential to shake the can for two or three minutes to mix the contents completely. While spraying, stop now and then for a few additional shakes.

To help atomize an aerosol paint, place the can in warm water, no more than 100 degrees, for fifteen minutes or so before spraying.

Though it's possible to clean hardened paint off an aerosol-spray nozzle with a straight pin, you can avoid this nuisance. Simply invert the can when your work is done and spray briefly until only clear propellant is emitted.

For your safety, spraying with either a gun or aerosol should be done only in a well-ventilated place, away from open flame and motors that may spark and ignite spray vapors. A well-made painter's mask, though it may feel uncomfortable at first, should be worn for all but the briefest spray jobs.

Restyling

Old Furniture

✿✿✿✿✿✿✿✿✿✿✿✿✿✿✿✿✿✿✿✿✿✿✿✿✿✿✿✿✿✿✿✿✿✿ A little effort and a lot of imagination can work wonders when it comes time to give old furniture a face-lifting. Sometimes all that's needed is a bright new paint job or a change of hardware. A piece that has good basic lines often is spoiled by poorly done, ornate carvings. These can be pried off with a chisel after the glue has been softened by applications of damp cloths.

More often than not, removing gingerbread molding, casters, and mirrors will greatly improve appearance. You may be surprised to find that furniture that always seemed old-fashioned has a clean, modern look after minor stripping has been done.

On the other hand, some furniture, particularly the low-priced unfinished variety, may need a bit of dressing up to give it distinction. Decals may do the trick on kitchen-chair backs. Add interest to a bookcase by enameling the outside and wallpapering the inside. For a pleasing contrast, stain the top and sides of a chest, then finish the drawer fronts with enamel.

You can get a lot of restyling ideas by becoming acquainted with some of the more unusual finishing materials available: metallic paints, crackle finishes, and adhesive papers, to name but a few. You will discover dozens more by visiting any well-stocked paint and hardware store.

On the following pages you'll find specific information telling you exactly how to transform old or inexpensive furniture into something very special. Although the techniques are the ones

103

The appearance of even a simple piece such as this kitchen stool can be enhanced with a two-tone paint job. Here, the edges are to be painted a second color, and masking tape is being applied to protect the seat of the stool from stray paint.

used by professional finishers, you will not need unusual tools or materials. Included in our bag of restyling tricks are flame finishing, distressing, antiquing, and stenciling. If none of these seem right for the furniture you want to work on, there's also a section on the fascinating art of decoupage, as well as step-by-step instructions for working with mosaic tiles and plastic laminates.

Flame Finishing

You may have to steel yourself to be able to burn the surface of a table or bench; it's hardly a conventional finishing method. But the results are invariably attractive.

Only two tools are needed: a propane torch and a stiff brush. Though there's nothing complicated about flame finishing, it

will be worth your while to spend a few minutes practicing with the torch on an inconspicuous part of the furniture, perhaps the underside, or on a scrap of the same sort of wood.

The basic idea is to char the surface of the bare wood as evenly as possible. The torch should be used with a stroking, spray gun–like motion. It's essential to keep the torch moving fast enough so that no part of the surface actually breaks into flame. This is especially important at edges, which tend to burn rapidly.

After you've charred the entire surface, go over the piece with a stiff brush, using with-the-grain strokes. This will remove

A flame finish is a good choice for almost any piece of inexpensive unpainted furniture.

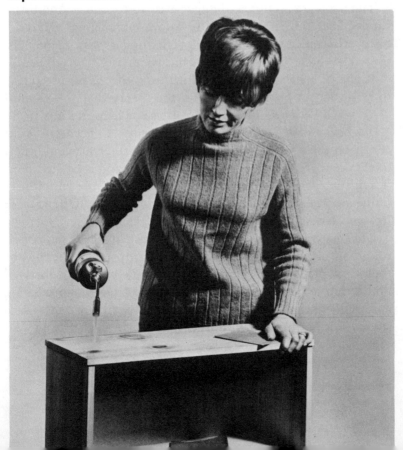

loose charred material. To heighten the contrast between light and dark areas, apply paste wax and buff with a soft cloth. The wax will also serve as a protective coat; no varnish or shellac has to be used.

Simple Early American–style furniture is most suited to flame finishing. Pieces made of fine cabinet woods are definitely not candidates for this treatment.

Distressing

Now that we live in a chromium, plastic, hurry-up world of instant everything, it's only natural that people lack patience to wait for their furniture to grow old gracefully. That's why more and more do-it-yourselfers are contriving ways to make not-so-old reproductions look very old, very quickly.

The name for all this skullduggery is "distressing." And furniture which has been subjected to various pummelings and other tortures to make it look old before its time is said to be "distressed"—which, in fact, it probably is.

If you're bent on distressing furniture, there's no use trying to talk you out of the idea, so on the theory that if you must do it, you'd better do it right, here are some helpful hints.

To begin with, we have a cardinal rule: Concentrate your efforts on those points where natural wear-and-tear would most likely occur. Normally, furniture is nicked and scratched most heavily on edges and corners. Surfaces around knobs and drawer pulls also usually receive some rough treatment. Often, table legs and bases are battered by careless feet.

The first order of business in the instant aging process is rounding of all sharp edges. Depending upon what's in your tool kit, a plane, rasp, or spokeshave can be used, Personally, I find a rasp to be the easiest, most foolproof tool for producing natural-looking edges. Remember as you work that the edges should not be rounded uniformily; if they are, the result will

be stiff and artificial. After you've rasped or planed to your satisfaction, finish off the edges with a medium-grit sandpaper. There's no need for a superfine smoothing job.

Now comes the fun. Use a hammer, preferably a small ball-peen model, to dent surfaces that would normally become dented in the course of time. The dents should not be uniform; you'll get good results by varying the force of your blows and by hitting the surface from different angles. To get the hang of this, you may want to pound away at a piece of scrap stock first. Of course, a hammer isn't the only tool that you may use. A length of chain, for example, makes a fine tool for distressing. It can be used to beat the wood or may be sawed back and forth over a too-perfect edge. For a more subtle denting job, an interesting variation is to pad the chain slightly by placing it in a burlap bag. If neither the chain nor hammer method appeals to you, make a miniature mace by driving nails of different lengths and thicknesses through a stick. Hammer them through haphazardly

Drive nails at random angles through the end of a stick, then string together some old keys and small hardware to make your own distressing tools.

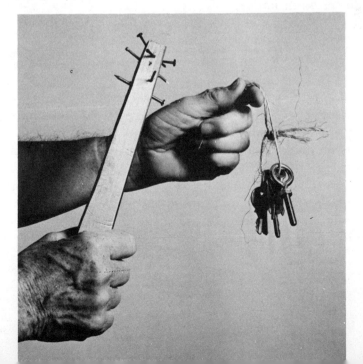

at varying angles. Then use the mace to create random holes and dents. A handful of old keys on a string is another excellent denting tool. In fact, almost any collection of miscellaneous small hardware on a string works well because each piece moves freely and so irregular dents are assured.

The hallowed rule of all experienced furniture-finishers is always to follow manufacturers' instructions. And one of the usual instructions is that all surfaces must be clean. But in distressing we part company with this rule. As part of the aging process, handfuls of dirt are rubbed into the piece. After thoroughly dirtying the surface, wipe it off. Some of the dirt will remain in the wood pores. Don't remove it, or you'll defeat the purpose behind this whole alarming procedure. The source of the dirt is a matter of personal choice. Some finishers swear by workshop-floor sweepings. Others insist that there's nothing quite like plain old garden dirt. If the thought of rubbing dirt into a perfectly good piece of furniture upsets you, consider this step optional. Or you can simply rub burnt umber into the distress marks.

After some discreet sanding here and there, stain the piece any color you desire. *If you plan to antique the wood, don't rub in dirt or burnt umber.*

Antiquing

Some finishers call it antiquing, others call it glazing. But call it what you will, it's probably one of the most impressive yet foolproof finishing techniques you'll ever try. And the results of your handiwork will have you swelling with pride.

In addition to the surefire results it offers, antiquing has another great virtue: It can be done over a previously painted surface, thus sparing you the ordeal of paint removal. Of course, if the old finish is peeling, it won't provide a good foundation and will have to be removed before antiquing.

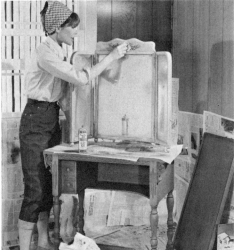

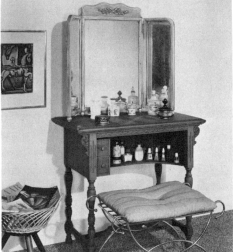

discarded and the cabinet made into a planter and dressing table. Two small squares of plywood, each fitted with a small wooden knob, replaced the doors missing from the left side of the cabinet. *(Top, right)* Base coat and glaze are sprayed over old finish. Newspapers on floor and walls give protection against spray mist. *(Center, left)* Base coat is wiped for desired effect. Old mirror, used with sewing-machine stand for dressing table, was sprayed a pale olive. Mirror was covered with newspaper and masking tape before spraying. *(Above)* The result is impressive, with the cabinet antiqued a deeper shade of olive than the mirror. *(Left)* For an instant change to a planter, the mirror is lifted off along with the cabinet cover, and the copper plant tray inserted.

(Top, left) An old sewing machine with lift-off cover and a three-part mirror were purchased for a few dollars at a second-hand store. The machine was

There was a time, not very long ago, when antiquing was strictly for the experts. They spent years and years experimenting with their own secret concoctions before finally arriving at the desired result. Now all this hard work is a thing of the past. Easy-to-use kits, containing everything you need to turn out a first-class antiquing job, are available in nearly every paint-supply shop.

Although the kits may vary slightly, a typical one would include these items: base paint, glaze, two paintbrushes, cheese-cloth, steel wool, and sandpaper. When you're shopping for a kit, you'll have no problem choosing one with the color you'll like because paint shops almost always have finished samples showing exactly what the result will be.

Antiqued furniture owes its distinctive appearance to the unusual way that the finish is applied. After putting on an opaque base coat, which is nothing more than a satin-finish enamel, and allowing it to dry, a glaze is applied. The glaze is a thin, translucent paint that is brushed on and then partially wiped off. This allows the base color to be seen through the glaze, producing a unique, aged effect.

Applying the Base. Just how you begin depends upon the furniture itself and the result you want. If you're going to antique a distressed piece, there's obviously no point in sanding. That would undo all the hard work that went into marring the surface and nicking the edges. In fact, every scratch and tiny crevice will retain the glaze and add greatly to the overall charm of the piece. Begin by cleaning the wood with Liquid Sandpaper or trisodium phosphate to remove all wax or polish. Don't omit this step; it takes only minutes and assures that the finish will bond properly. Then you slap on a coat of base paint. Don't worry a bit about brush strokes or any of the other usual niceties. Your only real concern should be to cover the entire surface. As you work, keep stirring the base paint so that pigment doesn't settle at the bottom of the container.

If you have a piece of modern furniture, you may well want a flawless, antiqued finish. In this case, you start by examining the surface and patching all defects. You follow up with a wax-removal treatment and careful sanding job. Then you apply a base coat. When it dries, you sand the piece lightly again and apply a second coat of base paint.

Applying the Glaze. When the base coat is completely dry, use cheesecloth or brush to apply the glaze coat. This can be a more carefree procedure than applying the base coat. Again, the main idea is to cover the surface completely. Aside from that, any marks left by a brush or rag don't matter a bit.

Chests and other large pieces should be glazed in sections to give you time to work. Any decorations or carvings should be done first so that they will have additional time to absorb the glaze. This will add attractive highlights. After you've applied the glaze, relax for about fifteen minutes. During that time the glaze will "set up" slightly. You'll know that the glaze is ready for wiping, even without timing it, when it begins to dull. It's advisable, if you've never done any antiquing before, to apply the glaze to the back of the piece, or perhaps to the underside, so that you'll be able to see how varying drying times affect results. And you'll have a chance to practice your wiping technique without feeling the doubts that you would if you went right to work on the front of the piece.

Wiping the Glaze. The way that the glaze is wiped, how much of it is removed, and how soon after application it is wiped all play an important part in determining the result. The base color can be kept subtle or made prominent, depending upon how much glaze is wiped off. The more glaze removed, the more visible the base coat. The best way to go about wiping is to remove a little of the glaze at a time, stopping often to inspect the work. Incidentally, you'll find it easier to measure your progress if you step back, as an artist does, so that you can judge the overall effect. You'll get different results when wiping, depend-

ing upon whether you're using wadded cheesecloth or a heavily textured material, such as a scrap of carpeting. But with any wiping material, the method is the same. Remove most of the glaze from the middle of doors and panels. Handles, sharp edges, corners, and other spots that would normally get a lot of wear should also be well wiped. Allow glaze to remain in carvings and decorations for interesting accents.

When the piece looks the way you want it to, let it dry overnight. After that, if you're still not satisfied, you can repeat the procedure by applying more glaze and wiping again. If, on the other hand, the base color isn't as intense as you'd like it to be, rub the surface lightly with fine steel wool or a very fine grade of sandpaper to remove the glaze until the desired effect is obtained.

The Finishing Touch. Most antiquing kits include a can of clear varnish that should be brushed over the glaze to complete the job. Because the glaze is a rather delicate coating, it's necessary to give it this protection so that it won't be accidentally stained or gradually worn off. Of course, if you've antiqued an ornament or a picture frame or some other item that won't be subjected to heavy wear, the varnish may be omitted.

Before applying the varnish, make absolutely certain that the glaze is dry. Depending upon the glaze used, how is was applied, and the weather, complete drying may take several days.

If your kit does not include varnish, you'll get good results with any name-brand satin-finish polyurethane varnish. If desired, a high-gloss varnish can be used, but usually such a finish is out of keeping with an antiqued surface.

Some manufacturers' supply of antiquing kits include in the package a second can of glaze. Such kits are not common, but if you work with one, wait until the first glaze coat is thoroughly dry before applying the second glaze. The purpose of double-glazing is to add another color. Unless you're unable to find a standard two-can kit providing the result you're after, there's no point in using a double-glaze kit. You may also come across antiquing materials packed in spray cans. These are usually

easier to use and faster than brush-on kits. Some of them make it possible to finish the job in one day.

Special Effects. Once you've tried your hand at antiquing, you may well become so intrigued with the process that you will want to vary the technique to achieve other effects. Let your imagination run wild. The possibilities are unlimited. To get you started, here are some suggested variations:

Marbleizing. For a crazed or marbleized finish apply the base coat in the usual way and allow it to dry. Then brush on the glaze. While the glaze is wet, crumple a sheet of plastic, such as a dry-cleaning bag or kitchen wrap, and place it on the glaze. Don't smooth the wrinkles; they create the pattern. Then without moving the plastic sideways, lift it carefully from the surface. The results are particularly attractive when a black base coat is combined with a white glaze, though, of course, other color combinations may be used if desired.

Mottling. Apply base coat and glaze as above; then crumple tissue paper, wrapping paper, paper toweling, or newspaper and pat the surface repeatedly. Use a straight up-and-down motion to avoid smearing or rubbing the glaze.

Tortoiseshell. If, as a child, you enjoyed fingerpainting, you'll have fun with this one. After the base coat is dry, apply glaze liberally, then tap the surface with your fingertips to create a random pattern over the entire surface.

Weathering. For an aged or weathered effect, apply a base coat and allow it to dry. Then apply a second coat of an enamel in any contrasting color. After this has dried, use medium-grade sandpaper or steel wool to remove part of the second coat so that the base color can be seen in some places, You can arrive at nearly the same result by lightly streaking the base coat with a second color. Use an almost dry brush and apply the second color in a random way.

Stippling. Apply base coat and glaze, then with a stiff, short-bristled brush, create a stippled pattern by simultaneously jabbing and twisting the brush in the wet glaze.

Speckling. Interesting irregular ringlike markings can be

made by spattering a glazed surface. The easiest way to do this is to run your thumb across the bristles of a toothbrush that has been dipped in turpentine or mineral spirits. Or you can apply the glaze itself over the base coat, using this same spattering technique. Whether spattering with solvent or glaze, it's wise to experiment first on newspaper to perfect your technique. You'll find that varying the pressure on the bristles, changing the brush-to-surface distance, and changing the amount of material on the brush can produce an infinite variety or results.

Graining. Use a clean brush to create fine lines by making long, continuous strokes through the wet glaze. Good graining technique demands an absolute minimum of brushwork. Go over the entire surface with a few decisive strokes, then stop.

Stencils

Art-supply shops and paint stores carry a wide variety of stencils. Or you can cut your own from a magazine illustration, a drawing you have done, or other artwork.

But no matter what the source, the working principle is the same; the stencil is simply a mask with carefully cut openings that form a design. When placed over the surface to be decorated, the stencil makes it easy to paint the design quickly and accurately.

If you decide to cut a stencil yourself, you'll need special stencil paper. This is a heavy, durable, oiled paper. You should also have a stencil cutter. For a trial effort, though, you can make do with any strong glazed paper and a new single-edge razor blade.

On a sheet of tracing paper, draw or trace the design you want. If your art ability is limited, don't fret. Simple designs are best, anyway. Remember as you work out your design that you'll be cutting it out later. So be sure that the design provides for

connecting strips of paper to support solid portions of the stencil that you want to remain.

When cutting the stencil, do as precise a job as you can. Be sure to make clean cuts; there must be no ragged edges. If you're going to make a repetitive design where the stencil will get a lot of handling, the paper should be strengthened by shellacking it. But even for a single application, if ordinary paper has been used to make the stencil, it should be thoroughly shellacked.

Either enamel or oil color in tubes can be used for the stenciling. The paint must have a thicker consistency than would normally be acceptable so that it won't tend to seep under the edges of the stencil.

After mixing the paint, tape the stencil to a scrap of wood so that you can test the stencil—and your technique. Ideally you should use a stiff, short-bristled stencil brush, but, lacking that, you can make your own by giving an ordinary brush a haircut. Tap the brush the way a woodpecker uses his bill—move it up and down with short strokes to work the paint into the stencil openings. Don't stroke the brush sideways; that would force paint under the edges of the stencil.

Let the stencil stay in place until the paint has dried. If you're impatient and move the stencil too soon, you risk smearing the paint.

Stenciling becomes more complicated when you're after more sophisticated results. For example, separate stencils have to be used to produce a design having many different colors. It's also possible to combine techniques effectively. After the stenciling has dried, freehand brushwork can add subtle shadings and highlights.

Stenciled designs on furniture that will be subjected to frequent handling or other hard use should be protected with a coating of clear varnish.

Squaring

Books, magazines, and catalogs are crammed with interesting designs and illustrations that are ideal for stencil cutting or even freehand furniture-painting. But the size is seldom what you need, and when you try to scale the artwork up or down, it may be difficult to keep the proportions correct and make an accurate copy.

By using the square method, you'll be able to enlarge or reduce any picture and still maintain its proportions exactly.

Here's all you need to do: Draw a square around the picture to be copied. Divide this square into a series of smaller squares so that a grid pattern is formed. On a separate sheet, draw another square proportionately larger or smaller, as required. Divide this square into the same number of squares as you did in the first square. To make the copy, simply duplicate the original, one square at a time.

Decoupage

Decoupage is the very fancy-sounding name for the craft of cutting out pictures, gluing them to furniture or other objects, and then varnishing to give an impression of depth.

It's not a new idea. In fact, some fine examples of decoupage were created in Italy as far back as the eighteenth century. But the materials at that time were crude and difficult to use, and the technique required considerable skill. Now, modern finishing materials have changed all that, and decoupage has become a craft that anyone can enjoy.

Decoupage can be used to decorate anything from a wastebasket to a wall. However, for a first effort, it is best to select a small object that you will be able to complete fairly quickly. After you choose something to decorate with decoupage, you will know what sort of pictures or designs will be most appropriate.

Finding interesting pieces of artwork that you can cut up to create designs may seem at first to be a big problem. But there are dozens of sources. You can buy prints, of course, some of which are sold specifically for decoupage, but part of the fun is tracking down the illustrations. You'll find it intriguing to hunt through magazines, old books, and even seed and plant catalogs. Nearly anything is fair game. Experienced *découpeurs* search through an almost incredible variety of material: old greeting cards, travel posters, and even wallpaper sample books. Incidentally, you might ask a wallpaper dealer if he is about to discard any of his sample books. If you can manage to get one, you'll be well supplied with excellent decoupage material.

When beginning, you'll find it easier to work with illustrations from magazines and catalogs. The stock used for wallpaper and posters is much thicker and consequently more difficult to cut and varnish.

Decoupage requires few tools. The most important is a pair of cuticle scissors in the smallest size you can buy. If you possibly can, find a pair having a curved blade.

Although using a pair of scissors may not seem to call for any special instruction, cutting a print for decoupage involves a

A tray or other small object is a wise choice for a first try at decoupage. Begin by carefully cutting out a picture of suitable size.

definite technique. In fact, you might want to do some practice cutting before working on the illustrations that you're actually going to use. For the cleanest possible cut, the paper must be continually fed into the scissors so that the cutting is done close to the blade's pivot point. The tip of the blade is used only when absolutely necessary, as when cutting into a corner or other tight spot.

The scissors should be held with the blade curving away from you. This will enable you to cut a bevel along the edge of the print so that none of the white paper underneath will show. When cut properly, the printed face of the paper will actually be a fraction larger than the underside. Later, when the paper is glued and you see how neat the edges are, you'll be glad you went to this trouble.

To give the paper additional body and make it easier to handle when cutting, spray the face of the print with two thin coats of clear plastic such as Krylon. But spraying in itself is no guarantee that the paper won't tear accidentally. To minimize the risk, cut out the center part of the print first. Allow the outer portions of the print to remain so that you have something to grasp while cutting the inner section.

The furniture that you are going to decorate with decoupage must have a perfectly smooth surface. If there are any dents or scratches, repair them before going any further. Although decoupage can be done over almost any finish, a painted surface is preferable to one that has been stained. Particularly pleasing results can be had by using decoupage on furniture that has been antiqued.

Arranging the cutouts to create an effective design is the next step. As you work, you'll find it helpful to hold the cutouts in place with bits of drafting tape. This can be removed without damaging the paper. After you've made a satisfactory layout, pick up one of the cutouts, remove the tape, and apply glue to the underside. A nonstaining, water-soluble adhesive such as

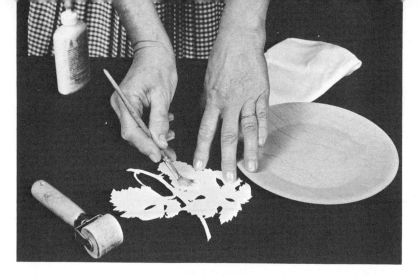

Apply a water-soluble white glue to the cutout, being certain to coat the entire paper, particularly along the edges.

Elmer's Glue-All should be used, but any other similar product will do as well. When gluing the cutouts to the surface, make certain that there is good overall contact by firmly pressing the paper into position. To avoid creating air bubbles, press the center first, then gradually work out to the edges. Some *découpeurs* simply use their hands for applying the cutouts;

Press the cutout in place with your fingers, then with a cloth pad and roller apply pressure over the entire surface to assure complete adhesion.

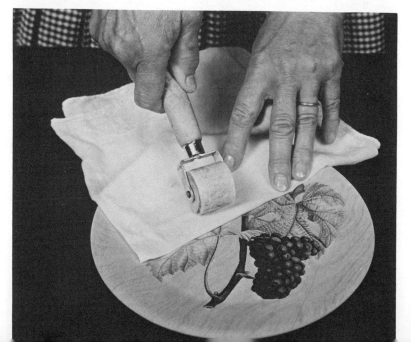

others prefer to use a small roller. If a tool is used, great care is needed to avoid marring the surface of the furniture or the cutout itself.

Sometimes, no matter how carefully you apply the cutouts, air bubbles may form. If this happens, slit the bubbles with a razor blade, and then apply a drop of glue with the point of a toothpick. Complete the repair by pressing the paper down firmly.

Use a sponge and warm water to remove all traces of glue from around the edges of the design. Do a thorough job; even the slightest bit of glue allowed to remain will become obvious when the varnish is applied. To avoid loosening the glue that is holding the cutout in place, use as little water as possible.

To create the three-dimensional effect that is the basis of decoupage, cost after coat of varnish must be applied. This may seem to be a lot of work, but it really isn't. The job will take a long time because at least twenty-four hours must be allowed between coats. But the actual brushing time is only minutes.

After a first coat of 50-50 shellac and alcohol, flow on coat after coat of varnish. Be sure to allow ample drying time between each coat.

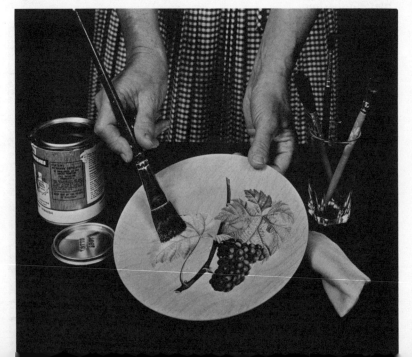

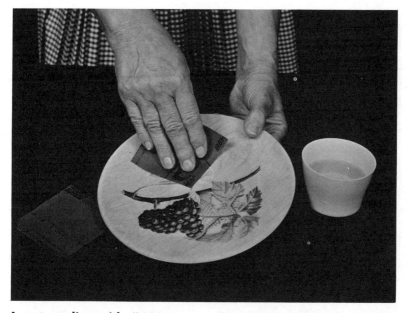

A wet sanding with #400 paper will produce a glasslike surface.

For a flawless finish, give the design a first coat of 50-50 shellac and alcohol. Allow this to dry for one day, then rub lightly with 4/0 steel wool. After wiping the surface clean, flow on a coat of varnish, taking pains to avoid brush marks. If any bristles fall on the surface, pick them off with the side of the brush. Wait at least twenty-four hours for the varnish to dry, then repeat the procedure until you have applied enough coats so that when you run a finger over the design, you cannot detect the edge. Depending upon the thickness of the paper, as many as twenty-four coats may be needed, but usually only twelve will do the job.

When you have reached this stage, sand lightly in a circular motion with #400 silicon-carbide paper soaked in water. To keep the surface level, back up the sandpaper with a felt-padded block. After sanding, clean the surface with a damp sponge.

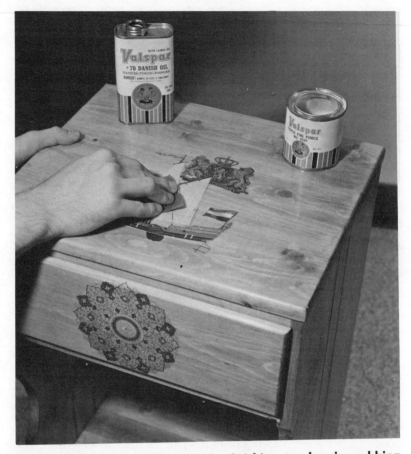

Some workers prefer to put on the finishing touches by rubbing with a felt pad charged with pumice and oil.

Repeat the varnishing and smoothing until you run out of patience, then as a finishing touch, rub in a circular motion with 4/0 steel wool and wipe with a clean, soft cloth. If you have any remaining energy, apply a light coat of furniture wax and buff it well. Butcher's Bowling Alley Wax is good for this purpose because it produces a fine luster and is colorless.

Tabletop Tactics

Covering up a surface is sometimes a better idea than refinishing it. For example, you may have an old table with a badly marred top. Although it is not ready for the scrap heap, it is also not worthy of a complete refinishing job. Instead of hiding the table in an attic or basement until you can reconcile yourself to throwing it out, you might consider covering the top. By covering the tabletop, you'll not only restore utility but also create a totally different look.

Plastic Laminates. You can buy plastic laminates at lumberyards in a wide variety of wood-grain patterns or colors. The wood patterns are often amazingly realistic. Most laminates are made in both high-gloss and satin finishes. For furniture, the satin surface usually is preferable.

Though I've never had any difficulty applying laminates directly over an old finish, manufacturers advise, as a first step, that the old finish be removed. This assures that the contact cement used to bond the laminate to the surface will hold securely. A belt-sander will make short work of this job. After removing the finish, fill any gouges with Plastic Wood.

For accuracy, it's a good idea to make a pattern of the tabletop on heavy wrapping paper, particularly if it's a free-form design. But if preferred, you can outline the tabletop directly on the plastic. If you are going to cut the plastic with a hand saw, use a fine-tooth crosscut. To avoid chipping, keep the face of the laminate up while sawing. A saber saw will speed the work, but here the procedure should be reversed: Turn the plastic face-down during cutting. The best blade for saber-sawing plastic laminate is one intended for metal-cutting. It should have at least thirty teeth per inch.

Specially made snips can also be used for cutting. Often these can be rented at the lumberyard where you buy the laminate. Whether you saw or snip, cut the material about $\frac{1}{16}''$ larger all around than the actual size of the tabletop.

Apply a liberal coat of contact cement to both surfaces to be joined, using a brush or a special toothed applicator. Depending upon the brand of adhesive used, you'll have to wait up to forty-five minutes for the cement to dry. Test the cement with a scrap of wrapping paper by pressing against the surface. If traces of cement adhere to the paper, allow more drying time.

When the cement has dried, align one edge of the plastic with the table edge. Then bring the plastic down into position. You've got to get this right the first time, because contact cement has a bulldog grip that makes repositioning impossible.

Go over the entire surface with a roller to make sure that the plastic is in complete contact with the tabletop. If you don't have a roller, a hammer used with a small block of wood to pad the surface can be substituted.

The edges of the plastic should be trimmed flush with a flat file. A block plane can be used instead, but it will dull rapidly. If the laminate has been applied to a large surface and considerable trimming is required, it will pay to rent a router equipped with a special bit made for laminate work. The edges of the table may be covered with laminate or molding.

Instead of resurfacing with plastic laminate, you can use mosaic tile. Tiles give an entirely different effect, of course, and come in an even greater variety of colors and patterns than plastic laminates.

Ceramic Mosaic Tile. Ceramic mosaic tile can be installed on almost any surface so long as it is clean and level. Paint should be removed, preferably by power-sanding, so that the adhesive will bond properly.

If you're going to use tiles of different colors, draw a graph-paper pattern to use as a guide. Use colored pencils to fill in the graph squares, each of which can represent one tile.

When you are satisfied with the pattern, lay out a few rows of tiles on the tabletop. If you use square tiles, you'll probably find

it necessary to cut some of them. Free-form tiles can usually be arranged so that cutting can be avoided.

An ordinary glass cutter may be used to score the face of the tile, which can then be broken along the line by snapping it between the jaws of two pairs of pliers. A plierlike tool called a tile nipper makes the job easier. It can be purchased or rented at any tile-supply house.

After cutting, the tile edge may be rough and should be smoothed on an inexpensive abrasive stone. Don't use a good oilstone for this work; the tiles are so hard that they will groove the surface and make the stone useless for sharpening.

With a notched trowel, apply ceramic-tile adhesive to the tabletop. The adhesive can be spread in any direction so long as the entire surface is coated. To apply an even layer of adhesive, keep the trowel teeth in contact with the surface throughout each stroke. Most tile adhesives are highly flammable. Turn off electric motors, fans, and heaters to reduce the danger of fire. Prevent buildup of dangerous vapors by providing plenty of ventilation. Except when you are actually applying the adhesive, keep the container tightly closed.

Set the tiles in the adhesive; press each tile firmly for a strong bond. If the tabletop is large, it's best to work on a section at a time, so that the adhesive doesn't begin to set before the tile is applied.

Depending upon the brand of adhesive used, allow from four to twenty-four hours for complete drying. Any excess adhesive can be removed from the face of the tile by carefully scraping with a single-edge razor blade.

Fill the joints between the tiles with grout. This is purchased in powder form and must be mixed with water to a creamy consistency. Apply grout over the entire surface with a trowel or squeegee. Work the mixture into the joints with a sponge. When the grout is almost but not completely dry, wipe off the excess with a clean sponge. Do a thorough job; hardened grout

cannot be removed. When the surface is completely dry, buff with wax for a high luster.

Grout is normally white, but it can be colored if desired. This is done by mixing dry grout with powdered grout color. After thoroughly stirring the mixture, water should be added according to the grout manufacturer's instructions.

All About Wood

Grain Patterns

✿✿✿✿✿✿✿✿✿✿✿✿✿✿✿✿✿✿✿✿✿✿✿✿✿✿✿✿✿✿✿ Anyone who works with wood inevitably become interested in trees and their characteristics. This study can, of course, become an involved one, but for most of us, simply knowing the general classifications will do for a start.

There are many of these classifications, but one of the more significant ones is based on the method of bearing seed. Gymno-

Cherry

Birch

Oak

sperms are characterized by their exposed seeds; they are ferti-
lized by wind-carried pollen. Coniferous, or cone-bearing, trees
such as pines, are gymnosperms. Angiosperms have their seeds
enclosed in an ovary and are fertilized by insect-carried pollen.
Deciduous, or leaf-shedding, trees are angiosperms.

From deciduous trees come the hardwoods so highly prized

Primavera

in the construction of fine furniture. Coniferous trees are no less valuable; they are the source of most of the lumber needed in building construction.

Hardwoods are sometimes termed porous woods because their sap vessels are composed of numbers of open-ended cells. After a hardwood log has been cut into lumber, the cells take on the appearance of minute grooves in the surface of the wood. These tiny grooves are the pores that are a distinctive characteristic of hardwood. In soft, coniferous woods, the ends of the cells are closed, and the woods are considered nonporous.

For anyone doing wood finishing, the size of the pores becomes particularly significant. Finishers classify woods as either

Pecan

Mahogany

Rosewood

Maple

Teak

open-grain or close-grain. Typical examples of open-grain woods are oak and walnut, but a number of other large-pored hardwoods are also included in the group. All of the open-grain woods are usually filled as part of the finishing job. Close-grain woods such as maple and birch have small pores and need only a thin filler. Other close-grain woods such as basswood, spruce, and holly have extremely fine pores and need not be filled. The characteristics of some common woods are indicated in the chart:

SOFTWOODS	HARDWOODS	
CLOSE-GRAIN	OPEN-GRAIN	CLOSE-GRAIN
Basswood	Ash	Apple
Cedar, red	Beech	Birch
Cedar, white	Butternut	Boxwood
Cottonwood	Chestnut	Cherry
Cypress	Elm	Ebony
Fir	Hickory	Holly
Gum	Locust	Maple
Pine	Mahogany	Pear
Redwood	Oak	Tupelo

Walnut

The sap vessels containing the cells that we commonly think of as pores are in a vertical distribution. There are other cells, horizontally arranged, known as medullary rays or pith rays. They extend inward toward the center of the tree, carrying food; they also conduct water outward.

The rays may be subtle in appearance, as they are in chestnut; or they may be bold and obvious in such a wood as oak. But in all woods, the grain pattern depends upon the size and distribution of the bands of cells that comprise the rays. In any given species, marked differences in grain pattern also may be caused by the method employed at the sawmill to turn the log into lumber.

A tree grows by a subdivision of cells in the cambium, a layer of tissue separating the bark and the wood. The outer, pale-colored wood just under the cambium is sapwood, so called

Grain patterns depend upon size and distribution of the cells in rays.

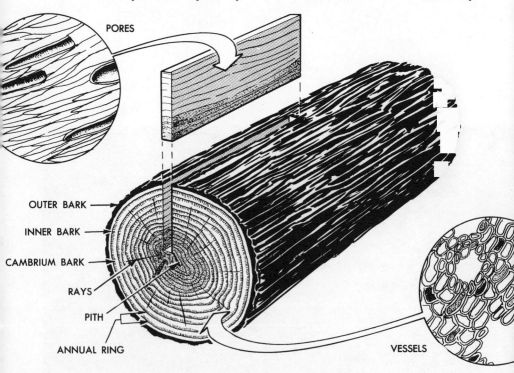

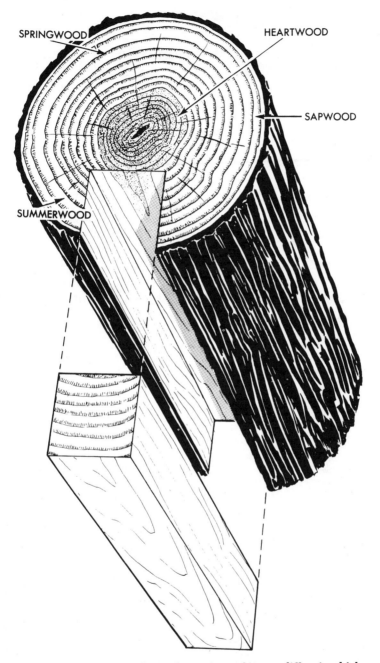

SPRINGWOOD

HEARTWOOD

SAPWOOD

SUMMERWOOD

Cross section of timber shows how tissue layers differ in thickness and color.

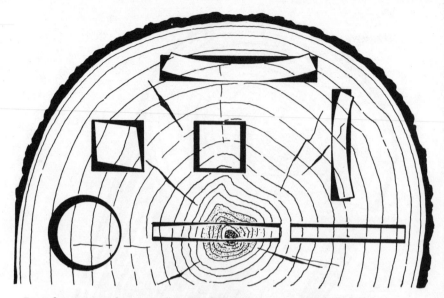

Boards are cut from timber in different ways; note their common warping tendencies.

End and side views of grain of quarter- and plain-sawed wood

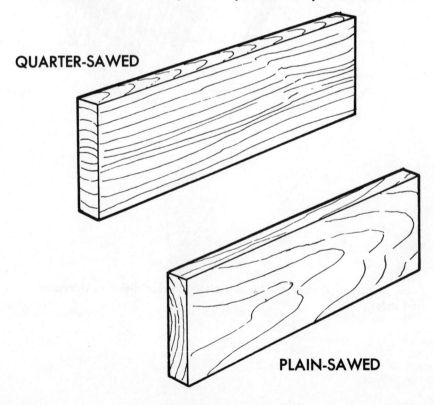

QUARTER-SAWED

PLAIN-SAWED

because it carries sap upward. The sapwood is not uniform in thickness, of course, and may also vary in color. Under the sapwood lies the heartwood, in a dense, dark core. Every spring a tree rapidly adds many cells to produce foliage. After the leaves appear, this cell production slows considerably. All this has a direct effect on the wood itself; the slow-grown summerwood is much denser and darker than the springwood.

Several terms are used to describe grain patterns that are produced by natural causes. When the annual rings are wide and prominent, the wood is said to be coarse-grained. If the rings are narrow and inconspicuous, the wood is described as fine-grained or close-grained. Where the annual rings vary greatly in width, the wood has an uneven grain. Or, if the rings are fairly uniform, the wood is considered to be even-grained. When the wood fibers parallel the log's axis, the resultant lumber is straight-grained. Fibers that spiral around the axis produce, as you undoubtedly expect, a spiral grain.

Sawing Techniques

Where nature stops, man takes over. By various sawing techniques, additional grain patterns can be produced. Lumber cut parallel to the rays is described as quarter-sawed; it displays a vertical grain. If it is cut perpendicular to the rays, it is said to be plain-sawed or flat-sawed. Diagonal grain results only from sawmill errors in which straight-grained timber is not cut parallel to the log's vertical axis.

Many spectacular examples of wood grain are produced when a log is cut into thin sheets for the manufacture of veneer. But beauty is not veneer's only virtue. By using veneer to cover less attractive woods, manufacturers are able to produce fine-looking furniture at relatively low cost. In fact, almost 80 percent of all wood furniture is made with veneer.

Four different sawing methods are used in veneer making; each produces an attractive figure, or pattern. Flat slicing involves cutting a halved log parallel to its center line by moving it up and down against a huge knife. The sheets of veneer produced vary in width but are as long as the log itself and show a variety of waves and ripples. Flat slicing is more often employed than the other methods.

Quarter slicing is done by running a quartered log against a blade at right angles to the annual rings. The figures range from stripes to flake patterns and are often used as inlays.

Rift cutting is most commonly used for oak; a quartered log is swung in an arc against the blade. This produces a striped pattern.

Rotary cutting results in a rippled figure when veneer is cut from birch or maple. As the term suggests, a whole log rotates against the blade. A continuous sheet results, equal in width to the length of the log.

Although much of the beauty of veneer depends upon man's skill, many particularly beautiful patterns result, sometimes almost unpredictably, because of the way that trees grow. Often, in certain species, an attractive pattern is found in veneer cut from the crotch of a tree. An accidental, wartlike growth called a burl may develop on almost any species and result in a beautiful meshed pattern. Veneers cut from the stump of a tree sometimes display a surprising variety of tones.

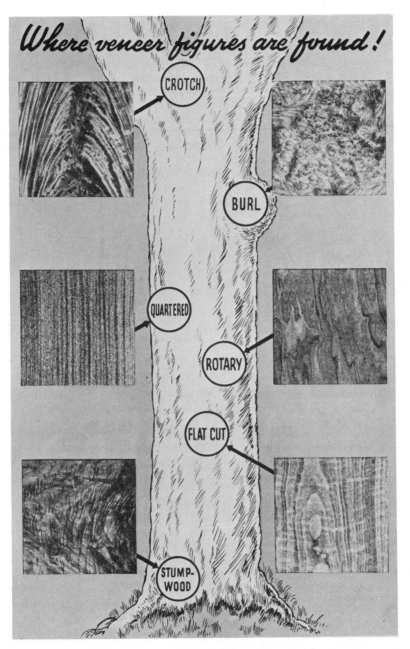

The natural variations in growth of different parts of a tree account
for the variety of veneer figures.

All About Glue

Adhesives

✿✿✿✿✿✿✿✿✿✿✿✿✿✿✿✿✿✿✿✿✿✿✿✿✿✿✿✿✿✿✿✿✿✿ When you build or re-
pair things using modern adhesives, the glued joints will very
likely be stronger than the articles themselves. But as effective
as they are, adhesives can't do their best job unless chosen care-
fully and used properly.

To help you select, here's a roundup of the adhesives most
often needed:

White glue is one of the handiest of the group. It does an
excellent job of joining wood, paper, cloth, leather, and many
other materials so long as at least one surface is porous.

The setting time is fairly short, usually about twenty to thirty
minutes. Although the glue is a creamy-white color, it dries
clear. When you're after an inconspicuous repair, you'll ap-
preciate the colorless drying characteristics of white glue.

Don't use white glue for outdoor furniture; it isn't water-
proof. At times, this can be turned into an advantage—if the
glue is too thick, simply add water to return it to its proper
consistency. It also washes off easily, whether on skin or clothing,
if you clean up while the glue is still wet.

For best results with white glue, it should be applied to only
one of the surfaces to be joined. On uneven surfaces two coats
may be required; for fabrics a thin coat will do; on wood joints
a generous spread is needed.

Epoxy cement is probably the most versatile adhesive. It pro-
duces enormously strong joints and is often used industrially to
join materials that would otherwise require brazing or welding.

Typical epoxy is packaged in two tubes: resin and hardener.

It costs much more than most other adhesives, but in terms of the work it can do, it's a bargain. Generally, it's packaged in two ½-ounce tubes; one contains adhesive or resin, and the other a hardener.

To use, you squeeze equal amounts from each tube onto an old saucer, a scrap of tile, or even a piece of cardboard. Measurement isn't critical; if the two ribbons are roughly the same length, the mixture will be correct. After stirring the two together (use a matchstick) until the color is uniform, apply a thin layer to both surfaces to be bonded.

While the epoxy sets, the parts should be clamped together, but don't overdo it. Too-tight clamping may squeeze epoxy out of the joint and cause weakness.

Epoxy hardens by chemical action, rather than by exposure to air. If you're not careful to put the caps back on their respective tubes, enough resin and hardener may team up to permanently seal the tubes.

Contact cement is most often used by professional workers, but it is especially valuable to the do-it-yourselfer who may be short of clamps. It bonds instantly on contact; thus no clamps are needed.

You can buy either of two types. One dries rapidly, but its vapors are highly flammable; the other is safer because of its water base, but it costs about one-third more.

Though contact cement is typically used to bond plastic laminates, it also works well with wood veneer, leather, fabric, and hardboard.

All parts of the surfaces to be joined must be covered with cement. Be generous; no harm will be caused by applying more cement than is actually needed. But if you apply too little, the bond will be a weak one.

After you've coated both surfaces, wait forty-five minutes for the cement to dry. Then examine the surfaces to be sure they are fully coated. If you see any dull spots, apply another coat of cement and relax for another forty-five minutes. You can test the surface for complete drying by pressing a scrap of paper against the cement. If any cement adheres to the paper, wait some more.

When the surfaces are dry, align them perfectly and press together. Once the surfaces touch, realignment won't be possible. To make alignment easier you can use a wrapping-paper slip sheet. Lay the slip sheet on the base surface—it won't stick, because a contact cement–coated surface will adhere only to a similarly coated surface. Place the mating piece on the slip sheet and align. Pull the slip sheet out gradually while slightly raising one edge of the top piece. Then with a hand roller or rolling pin, roll the surface to press the pieces firmly together.

Resorcinol glue is a boon to anyone faced with the problem of assembling a poorly fitted joint; it has excellent gap-filling properties in addition to being a very strong adhesive.

Resorcinols are packaged in two containers; one can is a powder catalyst, and the other is a liquid resin. The two should be thoroughly mixed and sparingly applied to the work. Room temperature, glue, and work must be no cooler than 70 degrees.

One limitation of resorcinols is the dark-brown color. They can't be used for repairs on furniture having a light finish unless you don't require an inconspicuous repair.

Resorcinol isn't an all-purpose adhesive; it's expensive and a bother to mix. But for certain jobs it's superb: waterproof repairs on outdoor furniture, fixing sloppy joints, and anywhere else that you must have superstrong assembly.

Casein glue has two interesting characteristics: It's made from

milk and isn't a bit fussy about being applied at low temperatures. You can use it down to 32 degrees with good results; if you're working in an unheated garage, that can be an important attribute.

Casein comes in powder form and can be mixed easily with cold water. The mixture has a working life of about eight hours. Gap-filling properties are good, but not quite equal to those of resorcinol. Don't use casein for fixing outdoor furniture; it is resistant to moisture rather than fully waterproof. Most manufacturers advise against using casein glue for bonding dissimilar materials.

Its best qualities, besides low-temperature performance, are strong joints, even on oily woods such as teak, and its comparatively low cost.

Liquid animal glue is an excellent general-purpose woodworking glue where waterproof joints are not needed. It comes ready to use and dries overnight.

For general woodworking jobs such as this one, liquid animal glue is an excellent adhesive.

(Left) Strong joints require not only the right glue but also adequate clamping. The clamps shown are inexpensive but effective. *(Right)* Applying new edging is easy with this beltlike band clamp.

(Left) Favorite clamp among professionals is the handscrew. Its wood jaws grip firmly without marring the work. *(Right)* You may not buy all these clamps at once, but to be able to handle a variety of jobs without having to improvise, you will eventually need them all.

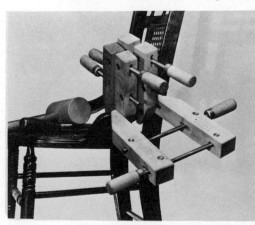

It is light in color and does a fairly good job of gap filling. Unlike many other adhesives, animal glue remains flexible after drying and will not powder.

Liquid animal glue works best above 70 degrees, but if the room is cooler than that, simply warming the glue will let you go ahead with the job.

The setting time is slower than most other glues, a great advantage on large work that may require repositioning.

Clamping. When using any glue except contact cement, clamping is important. It's most convenient to have an assortment of clamps so that you'll be able to handle various projects, but improvised clamps may be used instead. The weight of a stack of books, bricks, or even a bucket of water can hold work while the glue sets. For chair-rung repairs use a rope tourniquet. On small repairs you may be able to do enough clamping with rubber bands or masking tape.

A discarded hacksaw blade makes a good glue spreader; the toothed edge will assure uniform application. Many workers find it convenient, especially on large work, to apply glue with a paintbrush. If you try this, use a new brush; an old one may have traces of solvents that will react with the glue and interfere with adhesion.

When you're buying some of these adhesives, you might want to get some patching materials also. You'll need them for most any refinishing work that you'll be doing.

Patching Materials

Plastic Wood. Of all the patching products on the market, probably the best known is Plastic Wood. It is a ready-to-use cellulose-fiber material that adheres not only to wood but also to metal, glass, and stone. You may buy it in a can or tube, but unless you're planning to use it up quickly, I suggest that you

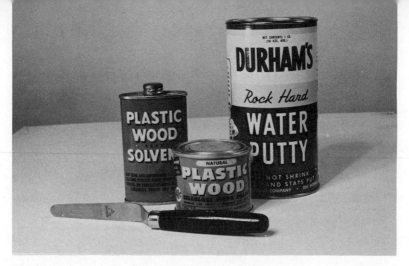

For furniture work and general household repairs you will find these patching materials indispensable.

choose the can. In a tube, if the material eventually hardens, it has to be discarded. But when packed in a can, all you have to do is remove the lid, pour in some Plastic Wood Solvent, and recap. After standing overnight, the Plastic Wood will be restored to its original consistency.

Before using Plastic Wood, make certain that the work surface is clean and dry, then press the Plastic Wood firmly into place with a putty knife having a flexible blade. For a smooth repair, wet the blade with Plastic Wood Solvent or lacquer thinner before drawing it over the patch. Don't keep troweling the patch; just draw the knife over it in a single stroke.

Because the material shrinks as it dries, the hole or crack should be overfilled rather liberally to compensate. Where large patches are required, it's best to apply thin layers, allowing each layer to dry before further applications. Finally, the patch should be sanded until level with the surrounding surface.

Inconspicuous patching is simplified with Plastic Wood because it is available in five colors: natural, oak, walnut, dark mahogany, and light mahogany. Two or more colors may be mixed together if necessary for accurate color matching. The handiest way to do this is to work on a piece of glass or tile. For easy mixing and good workability, you might have to add solvent or thinner.

Water Putty. An equally useful patching material is Durham's Water Putty. It comes in powder form and is mixed with water

to about the consistency of commercial putty by combining 3 parts powder to 1 of water. The mixture will adhere to wood, cement, tile, plaster, and stone. Thorough mixing is important; because of the rapid setting time, only a small quantity at a time should be prepared. If necessary, you can add a little vinegar or milk when mixing to increase the drying time.

Unlike Plastic Wood, Water Putty doesn't shrink as it dries. When patching, apply the material so that it is just barely higher than the surface; this will allow enough for finish sanding. But before you sand, wait at least one hour for the patch to harden. Water Putty is available only in a natural color, but when mixing, dry colors may be added to produce the desired result.

Stick Shellac. The favorite patching material among professional finishers is stick shellac. You can buy it in various wood colors or in transparent form. For repair of cracks and deep scratches that expose the wood, use one of the opaque colors; transparent stick shellac should be used on minor scratches that have not bared the wood.

Stick shellac is used by melting it on a hot knife blade, which is then pressed against the damaged spot to deposit the shellac.

Easy patching is assured if you use a springy blade.

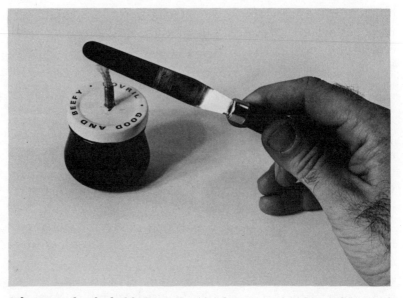

A homemade alcohol lamp is fine for heating a blade used for stick shellac. Make the lamp from any small jar and a piece of lamp wick inserted through a hole drilled in the cap. For a neater job, solder a small tube in the hole drilled through the jar cap, then feed the wick through the tube.

To do a good job you'll need a flexible blade. The one that I find most convenient is an artist's palette knife with a springy 3″ blade. For occasional use, however, you should be able to get by with a kitchen paring knife.

You'll also need an alcohol lamp or a can of Sterno to heat the blade. Don't use any other sources of heat; they may leave soot on the blade which will be transferred to the shellac. Woodworkers' supply houses, such as Albert Constantine and Son, carry alcohol lamps for this purpose.

When heating the knife, position it so that the flame is near the middle. Hold the shellac stick near the blade's tip so that

when the shellac melts, it will run onto the blade. After enough shellac has accumulated on the blade, it should immediately be pressed into the crack to be repaired. To avoid depositing shellac on the surface adjacent to the damaged spot, some workers mask the surface with tape.

Careful scraping with a single-edge razor blade will level the shellac. After scraping, light sanding with 6/0 paper backed by a felt pad will smooth the repair. For best results use a wet-or-dry sandpaper lubricated with water. Finally, rub the shellac with 4/0 steel wool to dull its sheen.

If the shellac doesn't provide a perfect color match, it may be touched up with stain, assuming, of course, that the shellac is too light in color. For this reason, when the desired shellac color isn't obtainable, it is better to apply a lighter color rather than a darker one.

All About Tools

Basic Hand Tools

✵✵✵✵✵✵✵✵✵✵✵✵✵✵✵✵✵✵✵✵✵✵✵✵✵✵✵✵✵✵✵ To do good work, you will need good tools. Many of them are fairly costly, but in the long run you will save by buying the best. A good tool not only far outperforms a cheaply made one but is also capable of lasting a lifetime.

The hand tools in the list below are especially important in furniture work, but you will also find them useful for general building and repair jobs. You probably already own at least some of these tools; the others may be added as the need arises.

BASIC HAND TOOLS FOR FURNITURE WORK

* Block plane
* Hammer, 16 ounce
* Crosscut saw, 10 point
* Coping saw
 Back saw
 Miter box
 Bit brace
 Auger bits, various sizes
* Hand drill
* Drill bits, various sizes
* Shoe rasp

Smooth plane
* Screwdrivers, 3″–6″
* Awl
 Nailset, $\frac{1}{16}$″
* Combination square
* Folding rule
* Oilstone
* Mallet
* Pliers
* Chisels, $\frac{1}{4}$″–1″
 Gouges, $\frac{1}{4}$″ and $\frac{3}{4}$″

File, mill * C-clamps, various sizes
File, flat bastard * Handscrews, various sizes
Spokeshave * Bar clamps
* Vise * Workbench

** The items marked with an asterisk will be needed for most furniture repairs and should be given priority when you are shopping for tools.*

Even the best of tools can't do a good job if used improperly. There's nothing complicated about using hand tools, but sometimes the correct technique may not be familiar. Some pointers for using the more common hand tools are included here as an aid to the novice.

Hammer. Avoid mashed fingers when driving a nail by holding the nail as close to the head as possible. If your aim is poor

Grip the nail close to the head, and a missed swing won't mash your fingers.

and you hammer your fingers, they'll suffer little damage because they won't be trapped between the hammer and the wood.

A good hammer is a well-balanced tool—if you hold it at the end of the handle. Shortening your grip reduces leverage and wastes energy. Sometimes you may be forced to hold the hammer close to the head, as, for example, when striking a light blow or driving small nails. But jobs such as these should really be handled with a suitably small hammer. The weight of the hammer recommended in the tool list is 16 ounces. For most men this will be a comfortable weight; female do-it-yourselfers should choose a 13-ounce model.

A trick worth remembering when pulling nails is to place a scrap block under the hammer head to protect the work and increase leverage.

When driving a nail in a tight place where you can't swing the hammer, simply turning the hammer and driving the nail with the side of the tool will solve the problem.

A carpenter's hammer is intended for driving and removing nails; most manufacturers warn against using such a tool for pounding any hardened metals. Disregarding this warning may lead to an eye injury; the hammer face may chip with almost explosive force if struck against another hammer or other steel surface. The hammer is also a poor choice for driving dowels or tapping wood joints together; use a mallet instead to avoid damaging the surface of the work.

Screwdrivers. Inevitably, screwdrivers are used for prying and other tough jobs that may damage the blade. In theory, of course, screwdrivers aren't supposed to be used for prying, but there are times when it's the only way to get the job done. An old trick among professional workers is to set aside an old screwdriver specifically for those jobs that you're not supposed to do with screwdrivers. That way, the other screwdrivers in the collection will not become chipped and will fit screw slots perfectly.

When you buy screwdrivers, get a full set; usually this will

save some money. Even more important than the possible savings, however, is that with a set you will have no trouble with poorly fitting screwdrivers. If you try to get by with only one or two screwdrivers, you're certain to be in for trouble with stubborn screws that are larger or smaller than the screwdriver tip.

The most useful screwdrivers are the ones having square shanks. Where extra leverage is necessary, a wrench can be used to grip a shank of this type. For furniture work this may not seem an important advantage. But if you are dismantling a

Here is a good set of screwdrivers, with man-sized handles and square shanks.

Point your index finger as you saw, and you'll stay right on the line.

piece for repair or finish removal, you might have to remove awfully tight screws.

Eventually the screwdriver tip may become worn or chipped. If this happens, the blade should be filed back to shape. Check the tip with a square after filing to be sure that you've done an accurate job.

Saws. The simplest sawing trick, and probably the best of all, is to grip the saw handle with your index finger extended. Try it. You'll be amazed how much more accurately you'll be able to cut.

If you're one of those people who thinks making truly straight cuts on wide boards is an absolute impossibility, here's what you should do: Mark your cutting line on both the face and edge of the wood. The line on the edge will let you know if you are tilting the saw blade.

Any material that you are cutting with a handsaw should be placed good-side upward. This is especially important with plywood to avoid chipping the surface that will be finished. For a particularly clean sawing job on plywood or any thin stock, clamp a strip of scrap wood on the underside and saw through both pieces.

If your handsaw has a straight-top edge, you'll find it handy for marking cutting lines. But when you do this you'll leave fingerprints on the blade that will eventually cause the saw to rust. You can oil the blade to keep it shining, but a better idea is to apply paste wax. This will not only prevent rust but will reduce friction and make sawing much less of an effort.

Chisels. The golden rule for chisels and all other cutting tools is to keep them sharp. Proper sharpening will produce an edge sharp enough to shave with. Straight back-and-forth strokes on an oilstone will do the job. Take pains to maintain the tool's original bevel. After sharpening, place the flat of the blade against the stone to remove the burr or wire edge. Only a few strokes will be needed to do this.

Assuming that you are right-handed, use your right hand to grip the chisel handle and apply cutting pressure. Guide the blade with your left hand. For easier, smoother cutting, any chiseling on edges of the work should be done with the tool held at an angle so as to make a shearing cut. For light cuts, work with the blade bevel facing upward. Where there is a great amount of wood to be cut away, turn the bevel down so that the chisel can bite in. Heavy chiseling may require pounding the handle; use a mallet for this purpose, not a hammer.

Power Tools

After you have acquired some hand tools and the skill to use them well, you'll probably become interested in adding power tools to your workshop.

Electric Drill. For furniture repairs, the most useful portable power tool is the electric drill. Choose a name-brand product to be sure of quality and easy service. Don't buy a drill having a chuck capacity greater than ⅜″. Larger ones are awkward to use and seldom necessary for woodworking.

An electric drill will not only bore holes but also mix paint, buff, polish, and even do a good job of rust removal when fitted with a circular wire brush. Many accessories are available to convert the drill to other applications such as sawing and routing.

Straight-Line and Orbital Sander. If you are more interested in refinishing furniture than in repair, your first choice among the portable power tools should be a combination straight-line and orbital sander. Try to buy one equipped with a dust collector or an adapter that will let you attach the sander to a vacuum-cleaner hose.

Saber Saw. For furniture construction, a saber saw is invaluable. It does a fine job on intricate curving cuts and yet may also be used for accurate straight sawing even on 2 by 4's. If you buy a saber saw, get a variable speed model; this feature greatly increases the tool's versatility.

Lathe. The next step up the line will take you to the stationary power tools. Most useful for furniture-repair work are the lathe and the drill press. In fact, without a lathe, you'll find it impossible to make replacements of turned table legs, chair rungs, and similar parts.

A large-capacity lathe is necessary for furniture work. The swing (the maximum diameter of work the lathe can accept)

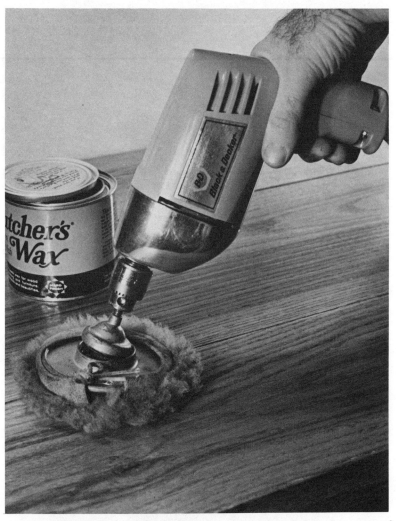

An electric drill is a valuable addition to any workshop because of
its great versatility. When fitted with a sheepskin pad it does a
fast job of buffing paste wax.

When you buy a wood lathe be sure to choose a model having sufficient capacity for your work. A 12" swing and 36" distance between centers should be the minimum size considered.

Invaluable for repair work of all sorts, the drill press is a basic tool in any well-equipped shop. For safety, the work should be clamped while it is being drilled.

should be no less than 12″. The distance between centers should be no less than 36″ so that long turnings can be made.

A wood lathe is not only a versatile tool but a fascinating one as well. For a creative person, it probably offers more intriguing possibilities than any other power tool.

Drill Press. Accurate drilling is sometimes a problem even for a craftsman, but with a drill press, anyone can do a perfect job. Capacity of a drill press is determined by the distance from the column to the chuck. Though most furniture repairs will not require a large capacity, other work probably will, so it will be best to buy a tool with at least a 7″ clearance between chuck and column.

The most useful drill press is the radial type. This has a head that can be tilted for angle drilling while the table and the work remain level.

As you know if you have shopped for stationary power tools, the cost is high. You may even have decided against buying because of the investment involved. But one manufacturer, American Machine & Tool Company, of Royersford, Pennsylvania, produces a full line of low-cost tools that I can recommend based on personal use. There are probably other tool manufacturers producing good power tools at low prices, but the AMT products are the only ones I have found so far.

The use of power tools involves many special techniques that are necessarily beyond the scope of this book. If you have purchased a power tool and are not familiar with its operation, I hope that you will take time to read any one of a number of books dealing with the subject. Authoritative books are published by some power-tool manufacturers; these are an excellent source of instruction.

❋❋❋❋❋❋❋❋❋❋❋❋❋❋❋❋❋❋❋❋❋❋❋❋❋❋❋❋❋❋❋❋ SECTION 7

Supplementary

Information

Finishing Schedules

Basic Lacquer Schedule (for coarse-grained woods)

1. Spray NGR stain. Dry 1 hour.
2. Fill with paste wood-filler. Dry as required.
3. Spray 1 coat sanding sealer. Dry 1 hour.
4. Sand with 5/0 garnet.
5. Spray 1 coat clear gloss lacquer. Dry 2 hours.
6. Sand lightly with 6/0 garnet.
7. Spray 1 coat clear flat lacquer.

Basic Lacquer Schedule for Finest Work
 (for coarse-grained woods)

1. Raise grain by wiping work with warm water. Dry 1 hour.
2. Sand with 4/0 garnet.
3. Apply water stain. Dry 12 to 14 hours.
4. Apply shellac wash coat. Dry 45 minutes.
5. Sand with 4/0 garnet.
6. Fill with paste wood-filler. Dry as required.
7. Spray 1 coat clear gloss lacquer. Dry 2 hours.
8. Sand with 5/0 garnet.
9. Spray 1 coat clear gloss lacquer. Dry 4 hours.
10. Sand with 5/0 garnet.
11. Spray 1 coat clear gloss lacquer. Dry 12 hours.
12. Rub with fine automobile rubbing compound.

160

Basic Lacquer Schedule (for fine-grained woods)

1. Spray NGR stain. Dry 4 hours.
2. Spray sanding sealer. Dry 1 hour.
3. Sand with 5/0 garnet.
4. Spray 3 coats clear gloss lacquer.
5. Rub to desired sheen.

Basic Varnish Schedule (for coarse-grained woods)

1. Apply NGR stain. Dry as required.
2. Apply shellac wash coat. Dry 45 minutes.
3. Sand with 5/0 garnet.
4. Fill with paste wood-filler. Dry as required.
5. Apply 2-pound–cut shellac. Dry 2 hours.
6. Sand with 5/0 garnet.
7. Apply 1 coat varnish. Dry 8 hours.
8. Sand with 6/0 garnet.
9. Apply 1 coat varnish. Dry 12 hours.
10. Rub.

Basic Varnish Schedule (for fine-grained woods)

1. Raise grain with warm water. Dry 1 hour.
2. Sand with 4/0 garnet.
3. Apply water stain. Dry 12 to 14 hours.
4. Apply shellac wash coat. Dry 45 minutes.
5. Sand with 4/0 garnet.
6. Apply 2 coats varnish. Dry as required.
7. Rub.

Shellac Schedule

1. Apply 1-pound–cut white shellac. Dry 45 minutes.
2. Sand lightly with 6/0 garnet.
3. Apply 2-pound–cut shellac. Dry 3 hours.
4. Sand lightly with 6/0 garnet.
5. Apply 2-pound–cut shellac. Dry 3 hours.

Stain and Shellac Schedule

1. Apply pigmented stain. Wipe. Dry as required.
2. Apply 2-pound–cut shellac. Dry 3 hours.
3. Sand with 6/0 garnet.
4. Apply 2-pound–cut shellac. Dry overnight.
5. Rub with paste wax on 000 steel wool.
6. Wipe with clean cloth and buff.
7. Apply as many more wax coats as desired, using cloth applicator.
8. Buff thoroughly.

Shellac and Wax Schedule

1. Apply 2-pound–cut shellac. Dry overnight.
2. Rub with paste wax on 000 steel wool.
3. Wipe with clean cloth and buff.
4. Apply as many more wax coats as desired, using cloth applicator.

Sealer and Wax Schedule

1. Apply penetrating wood sealer. Wait 30 minutes; wipe. Dry 4 hours.
2. Rub lightly with 000 steel wool.
3. Apply second coat of sealer. Dry overnight.
4. Rub with paste wax on 000 steel-wool pad.
5. Wipe with clean cloth and buff.
6. Apply wax with cloth and buff thoroughly.

Uniforming Schedule (for combinations of coarse- and fine-grained woods)

1. Spray NGR stain. Dry 1 hour.
2. Fill with paste wood-filler; wipe. Dry as required.
3. Apply pigmented stain to fine-grained wood. Dry 30 minutes.
4. Apply sanding sealer. Dry 1 hour.

5. Sand with 5/0 garnet.
6. Apply sanding sealer. Dry 1 hour.
7. Sand with 6/0 garnet.
8. Apply pigmented stain to all wood. Wipe as necessary to even the color. Dry 45 minutes.
9. Apply varnish or lacquer topcoats.

Early American Maple (for fine-grained woods)

1. Raise grain with warm water. Dry 1 hour.
2. Sand with 4/0 garnet.
3. Apply water stain. Dry 12 hours.
4. Apply shellac wash coat. Dry 45 minutes.
5. Sand with 4/0 garnet.
6. Apply 2-pound–cut shellac. Dry 3 hours.
7. Apply pigmented maple stain. Wipe. Dry as required.
8. Apply 2-pound–cut shellac. Dry 4 hours.
9. Apply several coats of paste wax, buffing well between coats.

Early American Maple (alternate method)

1. Apply pigmented maple satin. Wipe. Dry as required.
2. Apply 2-pound–cut shellac tinted to match stain.
3. Sand with 5/0 garnet.
4. Apply 2 coats of lacquer.
5. Rub lightly with 3/0 steel wool and liquid wax.

Old-World Walnut (also suitable for mahogany)

1. Spray NGR stain. Dry 1 hour.
2. Spray 1 coat clear gloss lacquer. Dry 2 hours.
3. Smooth lightly with 00 steel wool.
4. Apply pigmented wiping stain. Wipe. Dry as required.
5. Spray 1 coat clear gloss lacquer. Dry 2 hours.
6. Spray 1 coat clear gloss lacquer. Dry 3 hours.
7. Smooth with 000 steel wool.
8. Mix wax with powdered raw umber, apply, and buff well.

Pickled Pine

1. Apply NGR brown or gray stain. Dry 1 hour.
2. Apply 2-pound–cut shellac. Dry 3 hours.
3. Brush on white pigmented stain. Wipe for desired effect.
4. Apply 2-pound–cut shellac.
5. Rub with 000 steel wool.
6. Apply wax and buff completely.

Enamel Schedule

1. Apply 50-50 shellac and alcohol wash coat. Dry 1 hour.
2. Sand with 6/0 garnet.
3. Apply enamel undercoater. Dry as required.
4. Apply 1 coat enamel. When dry, sand lightly with 6/0 garnet.
5. Apply second coat enamel.
6. Rub down with 8/0 silicon-carbide paper used with water.
7. Rub with fine automobile rubbing compound.
8. Wipe with clean cloth.

Rubbing Schedule (satin finish)

1. Rub with 000 steel wool.
2. Buff with soft rag.

Rubbing Schedule (for high-grade satin finish)

1. Rub with FF pumice and water. Rinse well.
2. Rub with rottenstone and water or rubbing oil.
3. Apply paste wax and buff thoroughly.

Rubbing Schedule (for high-grade satin finish)

1. Sand with 9/0 silicon carbide lubricated with water.
2. Rub with fine automobile rubbing compound (medium grade)
3. Wipe with clean rag.

Note: This rubbing schedule requires somewhat less time and effort than does the preceding schedule.

Rubbing Schedule (polish)

1. Follow steps for satin finish.
2. Rub with automobile rubbing compound (fine grade).
3. Apply automobile liquid polish. Buff thoroughly.

Workshop Data

BOARD FEET FOR VARIOUS LUMBER LENGTHS

SIZE IN INCHES	8-FOOT	10-FOOT	12-FOOT
1 x 2	1 1/3	1 2/3	2
1 x 3	2	2 1/2	3
1 x 4	2 2/3	3 1/3	4
1 x 5	3 1/3	4 1/6	5
1 x 6	4	5	6
1 x 8	5 1/3	6 2/3	8
2 x 4	5 1/3	6 2/3	8
2 x 6	8	10	12
2 x 8	10 2/3	13 1/3	16

NOMINAL AND ACTUAL LUMBER SIZES (Inches)

NOMINAL THICKNESS	ACTUAL AVERAGE THICKNESS	
	SOFTWOOD	HARDWOOD
1/2	7/16	1/2
1	25/32	7/8
1 1/4	1 1/6	1 1/8
1 1/2	1 5/16	1 3/8
1 3/4	1 1/2	1 5/8
2	1 5/8	1 3/4
3	2 5/8	2 3/4

NOMINAL WIDTH	SOFTWOOD	HARDWOOD
2	1 5/8	(Customarily
3	2 5/8	sold with
4	3 5/8	edges unmilled)
6	5 5/8	

DRILL SIZES FOR WOOD SCREWS

SCREW SIZE	SHANK HOLE	PILOT HOLE HARDWOOD	PILOT HOLE SOFTWOOD
0	1/16"	1/32"	1/64"
1	5/64"	1/32"	1/32"
2	3/32"	3/64"	1/32"
4	7/64"	1/16"	3/64"
6	9/64"	5/64"	1/16"
8	11/64"	3/32"	5/64"
10	3/16"	7/64"	3/32"
12	7/32"	1/8"	7/64"

ABRASIVE-PAPER CLASSIFICATIONS

SIMPLIFIED MARKING	MESH NUMBER	SYMBOL
Superfine	400	10/0
Extra fine	320	9/0
Very fine	220	6/0
Fine	120	3/0
Medium	80	1/0
Coarse	50	1
Extra coarse	36	2

WORKSHOP SAFETY

Don't wear loose clothing when operating power tools.

Don't use an ungrounded electric tool (unless it is insulated).

Don't work with dull tools.

Don't keep rags with oil or paint on them; they may burn spontaneously.

Don't spray paint without wearing a mask.

Don't spray paint while smoking; turn off motors before spraying.

Don't use gasoline as a solvent.

Don't use lye for paint removal.

Mail-Order Sources

Sometimes the biggest bugaboo in furniture repair or refinishing is tracking down the materials or tools needed for a special job. When a local paint-and-hardware shop or lumberyard can't fill your order, you may be able to get what you want by writing to:

Adjustable Clamp Company, 406 North Ashland Street, Chicago, Illinois 60622. Send 25¢ for their catalog, which shows a complete line of excellent clamps and offers valuable suggestions on clamp use. This one is a must.

American Machine & Tool Company, Royersford, Pennsylvania 19468. They manufacture and sell directly a complete selection of well-made, no-nonsense power tools backed by a ten-year guarantee. Prices are extremely low; ask for a free brochure.

Behlen & Bro., 10 Christopher Street, New York, New York 10014. Everything you could conceivably need for wood finishing is here. A catalog is 25¢.

Brookstone Company, 831 River Road, Worthington, Massachusetts 01098. Their specialty is unusual hand tools and small power tools. Send 25¢ for a catalog.

Constantine & Son, 2050 Eastchester Road, Bronx, New York 10461. Their catalog has basic equipment for any finisher; it costs 35¢ and includes all sorts of hardware, veneers, finishing materials, tools, etc.

Craftsman Wood Service, 2729 South Mary Street, Chicago, Illinois 60608. A very extensive line of tools and materials is shown in this 35¢ catalog.

J. L. Hammett, Hammett Place, Braintree, Massachusetts 02184. A great variety of craft and art materials are listed in their 25¢ catalog.

Minnesota Woodworkers Supply Company, 925 Winnetka Avenue, Minneapolis, Minnesota 55427. An interesting catalog of varied items, but especially good for hardware; 35¢.

Nemo Tile Supplies, 177-02 Jamaica Avenue, Jamaica, New York 11432. Hundreds of patterns of mosaic and ceramic tile are carried here, along with the tools and materials needed to apply them. Send a letter outlining your needs, and they will quote prices.

Tandy Leather has stores in many cities: 3157 Wilshire Boulevard, Los Angeles, California 90005; 5945-47 West North Avenue, Chicago, Illinois 60639; 384 Fifth Avenue, New York, New York 10018. A fine selection of craft materials are listed in this free catalog.

H. L. Wild, 510 East 11th Street, New York, New York 10009. They carry an excellent selection of fine woods and veneers. Their catalog is 25¢.

Glossary

Across the grain: At right angles to the wood grain.

Annual ring. The layer grown by a tree in one year.

Antiquing: A finishing technique intended to create an aged effect. Glazing is another name for this technique.

Band clamp: A beltlike clamp used to apply pressure on glued joints on circular objects, chairs, etc.

Bar clamp: A clamp often used for tabletops and other large work. It is comprised of a pipe or bar with a quickly adjustable stop and a screw mechanism for tightening.

Bleeding: The softening of an undercoat by topcoat solvents. When this occurs, the undercoat will work into the topcoat and become visible.

Board foot: Designation for lumber measuring one square foot on the surface and one inch in thickness.

Brad: A small-diameter nail with blunt point and narrow head.

Butt: End-to-end joining without an overlap.

C-clamp: A clamp formed like the letter C which uses a thumbscrew for pressure.

Chamfer: A beveled cut, usually made with a plane.

Check: A crack along the grain of the wood caused by rapid drying.

Close grain: A tight arrangement of wood fibers which increases workability and facilitates finishing.

Coarse grain: A loose arrangement of wood fibers which impairs workability and makes finishing difficult.

Cross cutting: Sawing wood across the grain.

Decoupage: The art of decorating a surface with paper cutouts covered by many layers of varnish to produce a three-dimensional effect.

Découpeur: One who practices decoupage.

Denatured alcohol: A common solvent for shellac and paint.

Distressing: Intentional damaging of furniture to create an aged effect.

Edge grained: Lumber cut in such a way that the face is at right angles to the annual rings.

Ferrule (paintbrush) : The metal band between the handle of a paintbrush and its bristles.

Green: Newly cut lumber or lumber that has not been sufficiently seasoned.

Grout: A type of plaster used to fill the joints in tile work.

Hardwoods: Broad-leaved, flower-bearing trees as distinguished from coniferous trees. The actual hardness of trees in this category varies greatly; for example, both balsa and maple are ranked as hardwoods.

Jig: A device, often improvised, to make it easier to use a particular tool or to perform a certain operation.

Kiln: An oven used for drying lumber.

Laminated: Layered construction that produces great strength; plywood is one example.

Laminated plastic: Smooth, hard-surfaced material, often used for tops on counters and tables; Formica is one such product.

Lumber: Boards and planks cut from a log at a sawmill.

Member: One part of an assembly or structure.

Miter joint: A joint having the corner angle divided equally between the two parts of the joint. Usually each is cut at a 45-degree angle.

Mortise: A slot cut into a piece of wood to accept a tonguelike piece called a tenon.

Nail set: A tool used to sink the head of a finishing nail below the wood surface.

Naphtha: A chemical often used as a cleaning agent.

Oil colors: Colors ground to a paste in linseed oil.

Orange peel: A bumpy surface resembling the skin of an orange, caused by improper paint spraying.

Paste filler: A filling material used in wood finishing.

Primer: The first coat of finishing material.

Rabbet: A recess cut on the end or edge of a board to accept another member.

Rasp: A filelike tool used for shaping wood.

Rottenstone: A fine-powdered limestone used as a polishing agent.

Router: A motorized hand-held tool used for a great variety of inletting, shaping, and carving operations.

Rubbing compound: An abrasive mixture made in various grades, intended for rubbing down lacquer finishes.

Sanding sealer: A thin lacquer or shellac often used over bare wood to facilitate sanding. This material may also be used to seal a filler.

Softwoods: A botanical classification for trees bearing cones and having needles or scalelike leaves. The actual hardness of the wood has no bearing on this classification.

Spline: A thin strip of wood which fits into a slot or groove to strengthen a joint or fasten another part.

Spokeshave: A planelike tool used for shaping wood edges.

Squeegee: A tool with a blade, usually of hard rubber, used to press moisture from a surface or to insure good overall contact when gluing large surfaces.

Stick shellac: Shellac in solid form used for filling cracks and holes in wood.

Tack rag: A cloth that has been made sticky by the application of varnish, used to wipe dust from a surface just before finishing.

Tipping off: A light stroking of a surface with the very tips of the brush bristles to smooth a finishing coat.

Topcoat: The final coat of finishing material or any coat applied over another.

Trisodium phosphate: A cleaning preparation used to remove grease, dirt, or wax before applying a finish.

Vehicle: The liquid portion of any finishing material.

Water white: A term used to describe certain clear lacquers and varnishes which are transparent.

Index

Illustrations indicated in **boldface**.

176 All About Antiquing and Restoring Furniture

Hardwoods
 characteristics of, 130, 133, 170
 drill sizes for screws in, 166
 lumber sizes, 165–166
 stains imitating, 74–75
Heartwood, 137
Heat marks, treatment of, 3–4
Hickory wood
 characteristics of, 133
 filler mixture for, 80
Holly wood
 characteristics of, 133
 filler mixture for, 80
House paint, drawbacks of for furniture, 96
Hydrogen peroxide, for cleaning marble or tile, 9, 10

Ice cream stains, 3
Ink stains, removal of
 from marble or tile, 10
 from wood, 2
Inside corners
 brush techniques for, 87
 spray techniques for, 98
Internal-mix spray-gun nozzle, 92, 93
Iodine, for treating wood scratches, 5

Johnson's Jubilee Wax, 2
Joints, loose, repairing of, 10–14, 144

Kelobra wood, filler mixture for, 80
Kitchen
 chairs, redecorating of, 103
 stools, two-tone painting of, 104
Korina wood, filler mixture for, 80
Krylon plastic, in decoupage, 118

Lacewood, filler mixture for, 80
Lacquer
 as finishing agent, 68–70
 as ingredient of sealer, 82
 preparation of brush, 85
 spray technique, 93
 steps in finishing process, 160, 161, 163
 thinner for, 69, 89
Lacquered wood, treating scratches on, 5
Laminates, plastic, 123, 170
Lap marks, prevention of, 69, 77–78, 87
Lathe, 156, 158, 159

Lawn furniture, see Outdoor furniture
Linseed oil
 boiled, in finishing process, 72, 79
 in conditioning brush, 85–86
Liquid animal-glue, 143, 145
Liquid Sandpaper, 60, 110
Locust wood
 characteristics of, 133
 filler mixture for, 80
Loose casters, tightening of, 22–23
Loose hinges, treatment of, 20, 22
Loose joints, repairing, 10–14, 144
Lumber
 cutting of, 135, 136, 137–138
 data on length and sizes, 165–166
Lye, as paint remover, 37–38, 167

Mace for distressing, 107–108
Magnolia wood, filler mixture for, 80
Mahogany
 filler mixture for, 80
 grain pattern of, 131, 133
 refinishing of, 78
 schedule for finishing, 163
 treatment for scratches on, 5
Mail-order suppliers, 167–168
Mallet, 27, 150, 152, 155
Maple
 finish
 stain for, 74
 treating scratches on, 5
 wood
 filler for, 78, 80
 grain pattern in, 132, 133
 refinishing of, 78
 veneer, cutting of, 138
Marble and tile, treatment of stains on, 9–10
Marbleized finish, 113
Medicines, spilled, 2–3
Medullary rays, 134
Metal
 furniture
 repairing, 31, 33
 spray painting, 96
 surfaces, brightening agent for, 58
Methylene chloride, in paint remover, 37
Milk stains, treatment of, 3